THE
JAPANESE
TATTOO

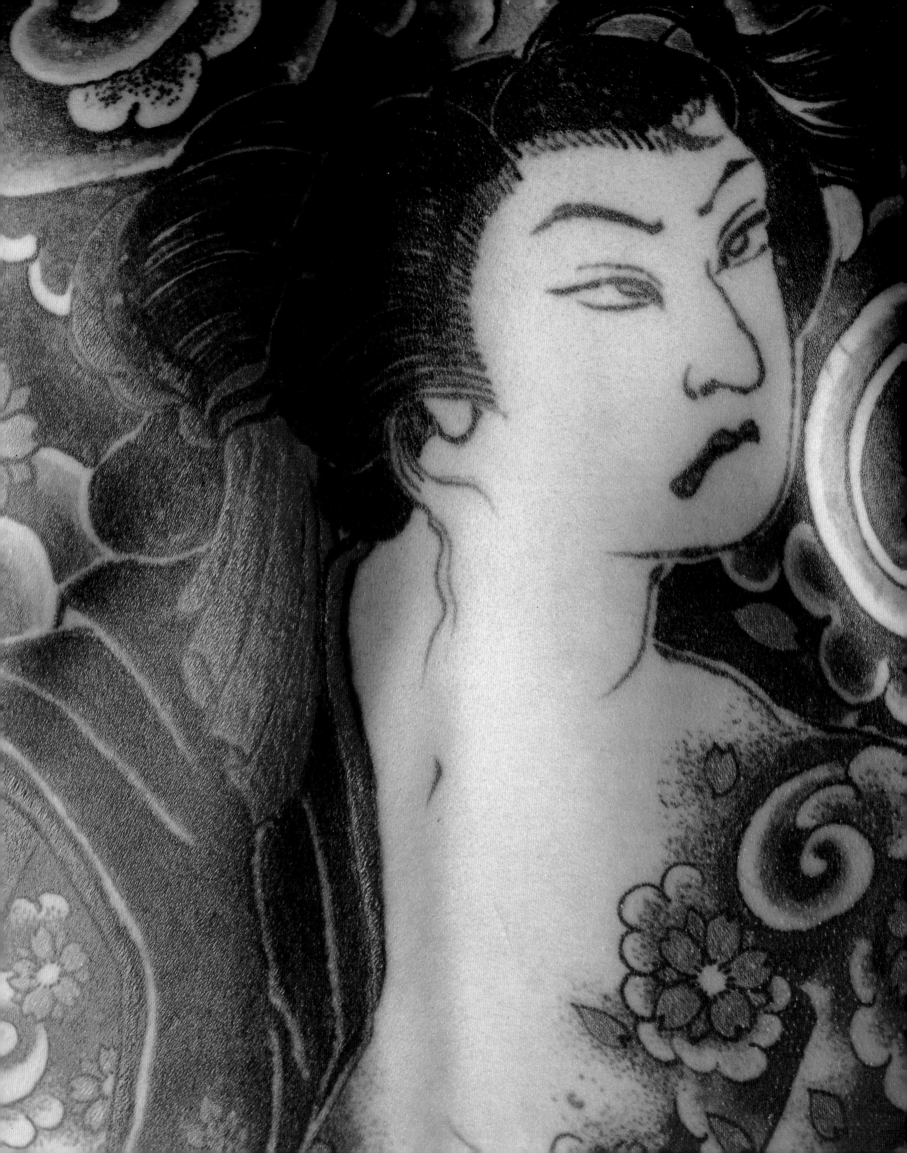

THE
JAPANESE
TATTOO

Photographs and Text
by
Sandi Fellman

Introduction
by
D. M. Thomas

Abbeville Press Publishers
New York London

Editor: Walton Rawls

Art Director: James Wageman

Designer: Philip Sykes

Library of Congress
Cataloging-in-Publication Data

Fellman, Sandi.
 The Japanese tattoo.

 1. Tattooing—Japan. 2. Japan—
Social life and customs. I. Title.
GT2346.J3F45 1986
391'.65'0952 86-14021
ISBN 978-0-89659-798-3 (pbk.)

First edition
20 19 18 17

For bulk and premium sales and for text
adoption procedures, write to Customer
Service Manager, Abbeville Press,
655 Third Avenue, New York, NY 10017,
or call 1-800-ARTBOOK.

Visit Abbeville Press online at
www.abbeville.com

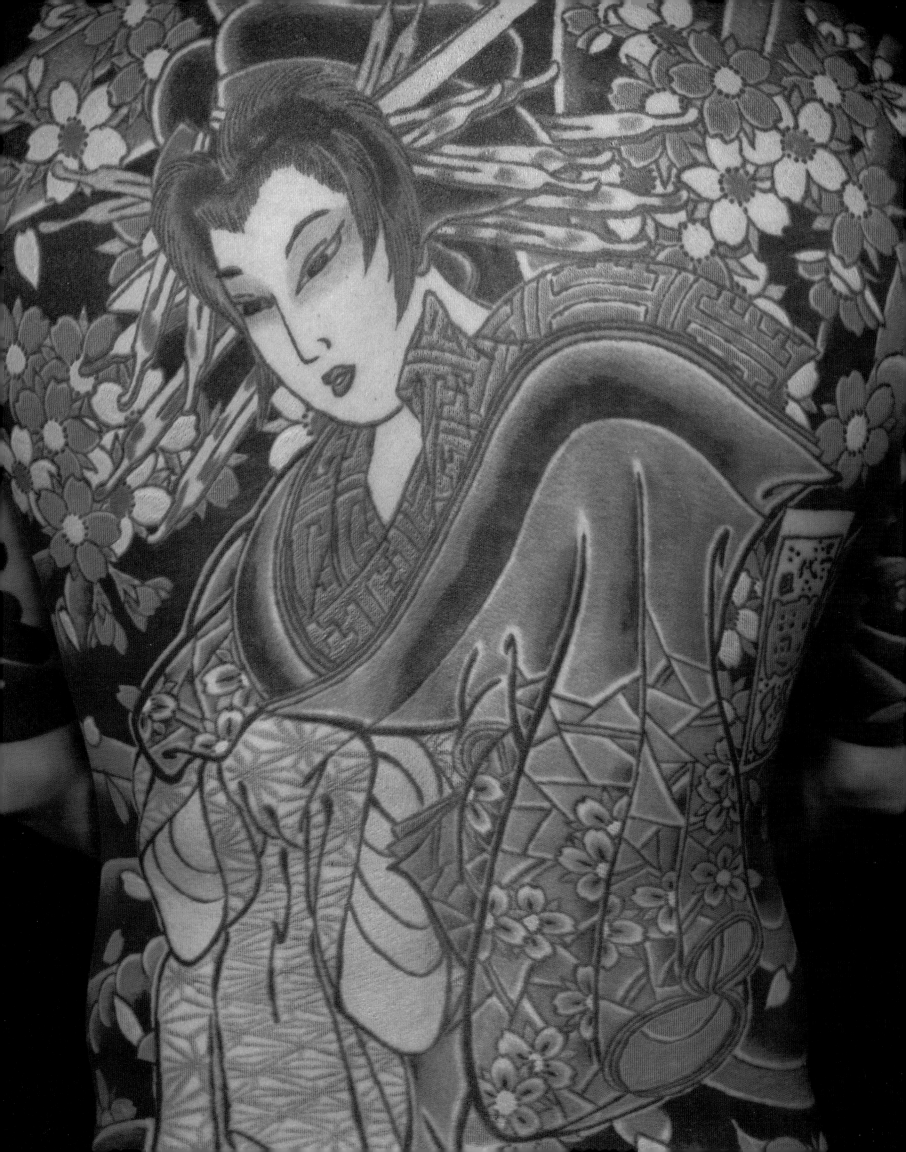

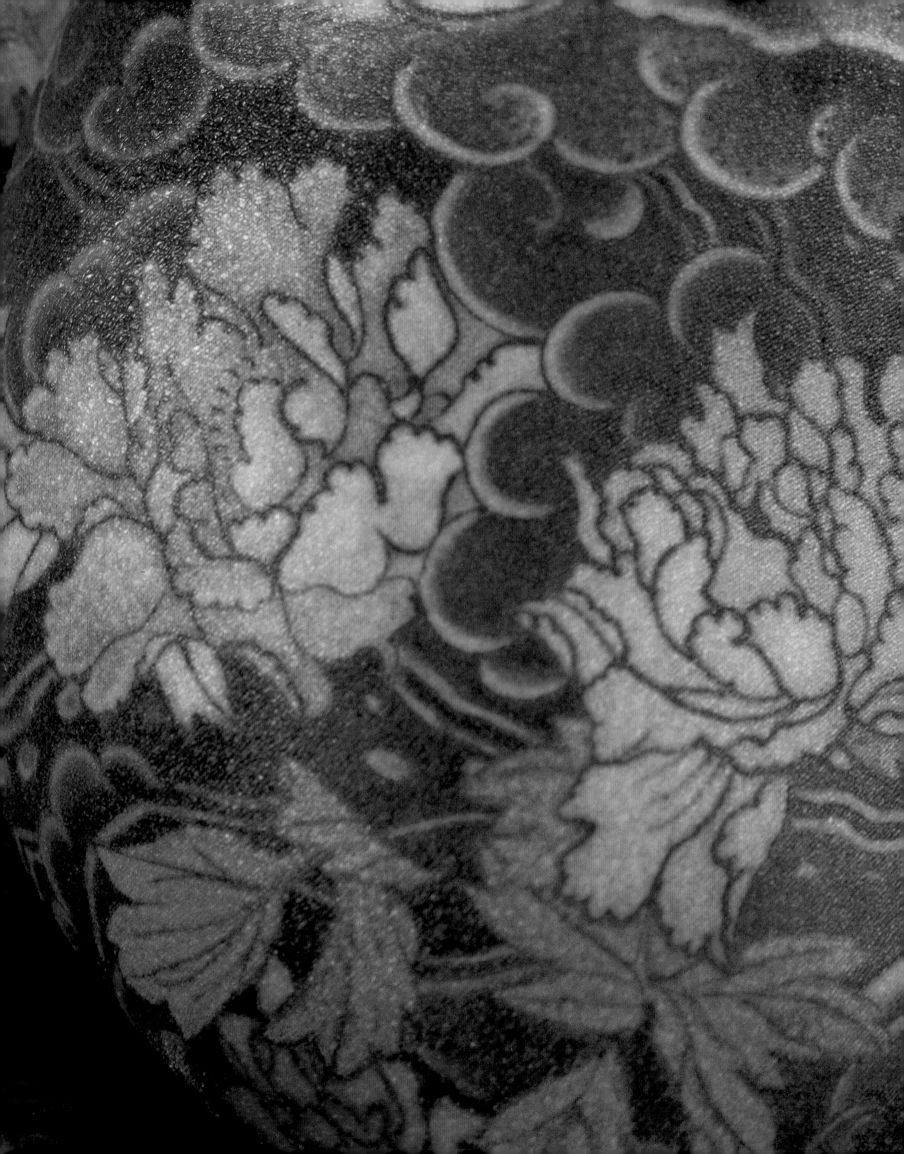

CONTENTS

INTRODUCTION
by
D. M. Thomas

Irezumi is a defense, a shield. The tattoo says, If you approach too closely, beware! It is like the Medusa, with snakes in her hair, of Western mythology, and like Keats's snake-woman, the Lamia . . .

> Eyed like a peacock, freckled like a pard,
> Vermilion-spotted, and all crimson-barr'd . . .

The irezumi's skin, which has borne the fiery pain of the needles, becomes cool, reptilian. The images of dragons, jagged lightning flashes, fish scales, and the ripplings of the moving body that a photograph cannot capture, increase the effect of a defensive barrier. Do the irezumi defend themselves against their emotions? Against the technology, consumerism, and conformism of modern Japan? The commuter in his business suit, who is secretly wearing feminine underclothes, may be an irezumi. Secrecy. Separateness. The mirror. Recognition of an artist's work can assume macabre, practical overtones in the case of the Japanese tattoo masters: it can help to identify a murder victim.

Every irezumi—a living painting! Imagine it in the United States. A mangled corpse is dredged up from the Hudson River. "Send for the master." He is taken into the morgue, inspects the poor victim, and says, "Undoubtedly a Chagall." Cops and medics crowd around eagerly as the expert points out the unique qualities of the master. The word spreads: "We brought up a Chagall this morning." Then the Metropolitan Museum becomes interested, bids for it, adds it to the Picasso-prostitute knifed in her room the previous month. . . .

Idea for a Japanese short story. A master looks at the corpse of a young man, once his homosexual lover, and says, "This is a Horiyoshi." He is divided between admiration and jealousy. He does not look at the young man's face.

East meets West in this book. Sandi Fellman's clear and intelligent art makes use of the most advanced photographic technology. Her subjects are people who have chosen to suffer years of torture, and perhaps even shortened their lives, in order to make their bodies look unnatural. East meets West, yet the two do not hold together. They seem to struggle against each other, and shy away. What was happening in the mind of the artist, as she took the photographs, and in the minds of the irezumi who allowed her to do so? Such questions do not occur to me in the case of the more conventional photography; they occur to me here because of the sheer alienness of the subjects. I can no more get inside their painted skin than I can get inside the carp that adorns many of them.

I find—I should add—the Japanese car worker, who writes a suicide note to his boss instead of his wife, equally unknowable.

Zen Buddhism teaches that enlightenment comes from within, not from an external agency. The tattoo becomes a manifestation of the man or woman's inner life. What pictures would modern Europeans or Americans choose as manifestations of their inner reality? Most of us, I suspect, would find it difficult to choose a symbolism capable of expressing our deepest values. The more sensitive would fall back on subjective imagery, such as the depiction of a loved person, but the

streets would also be filled with the faces and bodies of fashionable idols—football players and TV personalities. Symbolism, in our culture, is dead.

And how would we suggest, without the aid of dragons, lightning flashes, devils, and skulls, the dark side of our souls? We would probably not dare to; instead, we would safely externalize it. Antinuclear protesters would be marked with mushroom clouds, antivivisectionists with tortured rabbits.

Under the painted skull of Horikin is a mind more alive with signals than all the microcomputers of Sony; and under all of those signals lies the unconscious. Compared with that cosmic design, that tattoo imprinted by living, all his years of art are less than one touch of his needle. Yet—to an extent, at least—he wears his life on his skin, and it would be easy to imagine a psychotherapy based on the analysis of tattoos. It would not be necessary to associate from dreams; the dreams would be visible. Of course, the personality of the tattooist would be a complicating factor—and therefore an enrichment. Jung, with his emphasis on the archetypal, would have found the irezumi marvelous subjects; Freud would have traced the sadism of the tattooist, the masochism of the tattooed, to the Oedipus complex. The art of irezumi, we learn, may have begun with the branding of malefactors. "These men," Freud might have said, "still wish to be punished for their incestuous and parricidal desires. They would prefer to be flayed—but that will come after their death." Maleness, machismo, coupled with the grotesque . . . that seeming contradiction is built into the myth: the same used to be said of white girls in relation to black men. We return to the mixture of seduction and repulsion, in face of perverse. Most of us, from time to time, use sex as a needle to break through the unfeeling skin of routine existence.

Looking at the woman's back in this book, I know that making love to her would be making love to the tattoo more than to the woman. The wives of the male irezumi, Ms. Fellman suggests, experience that erotic displacement. It is not unlike the fetishist's need to interpose a symbol—fur or leather, garter belt or high-heeled shoes—between himself and his naked lover. Both fetishism and irezumi are largely the preserve of men; but also of magical and creative power: for love can be strengthened by the conjunction of a symbol.

Still, it would not surprise me if, for most irezumi, the deepest relationship is with the master, so tirelessly penetrating them.

I, a writer, an improvisor with words, envy and admire these artists who can bring their work, each day, to a point of completion. Not for them the wastepaper basket, piled high with rejected drafts; they cannot rip off the patch of skin and say, "We'll begin again." Each session must produce the equivalent of a perfect haiku, in which the ephemeral and the universal touch. Do the tattoo masters ever experience the despair of Western artists when things will not go right? Or that rending of the spirit described by Yeats: "The intellect of man is forced to choose / Perfection of the life or of the work"? I suspect they do not. I wish I knew their secret. Sandi Fellman's book does not and could not provide the answer; but it has made me more aware of the question—and of other, equally fascinating, questions—and I am grateful.

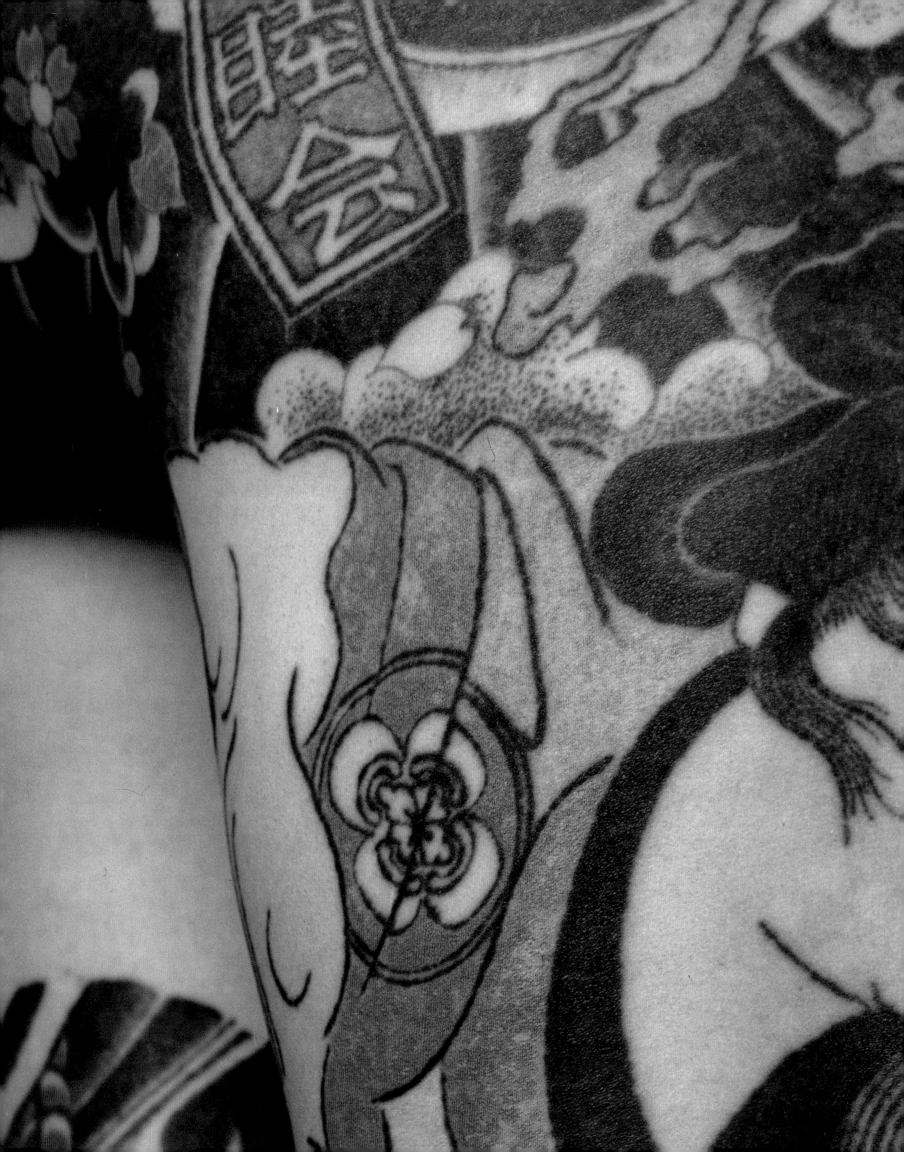

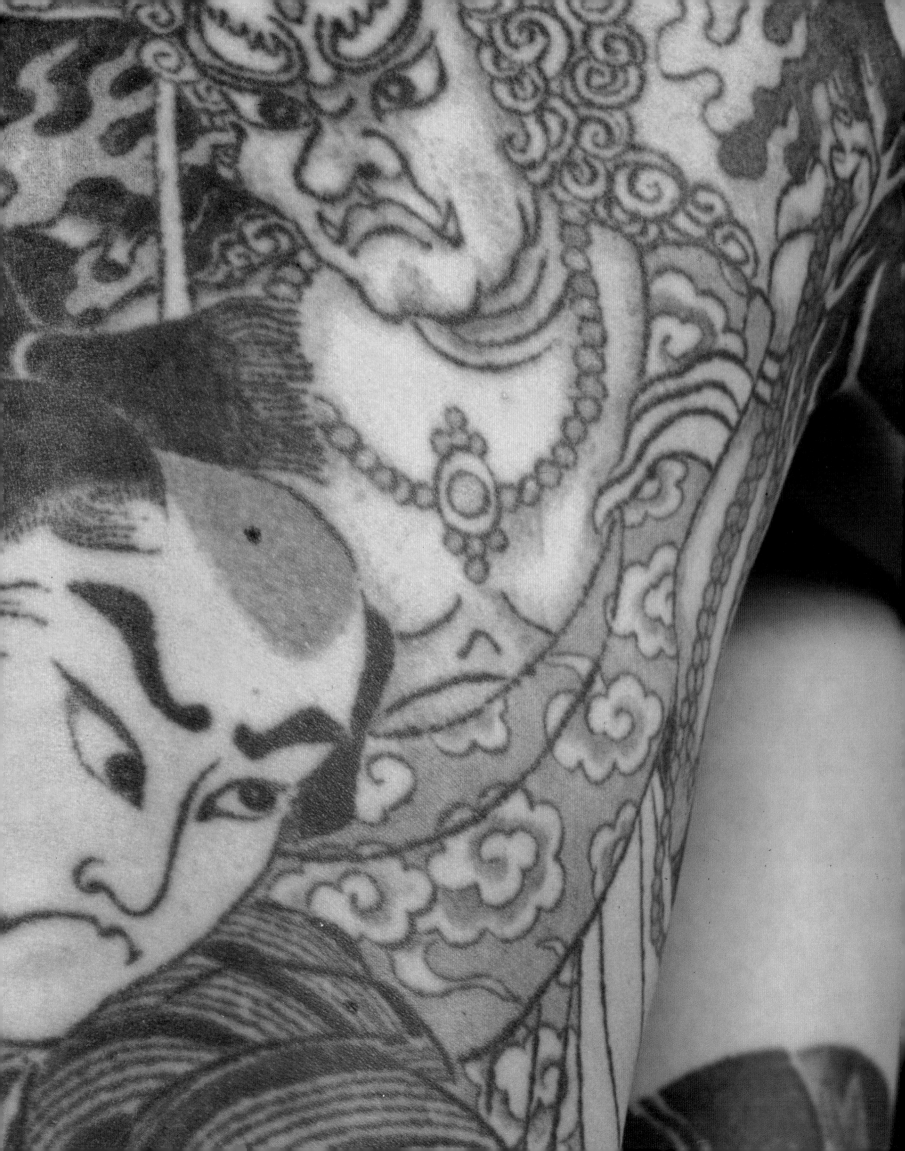

Spirituality
and
the Flesh

THE
JAPANESE
TATTOO

In the summer of 1982, in my New York studio, I photographed my first tattoo. Immediately after Adrienne arrived, she peeled off her sundress and displayed an exquisitely tattooed dragon down the length of her back. She told me, among other things, that for wedding presents she and her husband had given each other matching bat tattoos on their breasts. Adrienne also had rings in her nipples; she was exotic, and mysterious, and I was enthralled.

That fall I attended the opening of an exhibition of my photographs in Tokyo, and it seemed a perfect opportunity to pursue my newfound interest in tattoos. I knew that the Japanese had taken the art of tattooing to its extremes. Those with tattoos, the *Irezumi,* were a very secretive group of people, and finding them was my first problem. Their reputation as part of the underworld, and their underground existence, enhanced the obstacles to locating them. Ultimately, it was an American living in Japan, Donald Richie, himself an authority on the Japanese tattoo, who helped me make my initial contact. Following Japanese protocol, Mr. Richie was able to provide me with the customary introductions. He led me to Mitsuaki Ohwada, world-renowned tattoo artist, and my knowledge of Japanese tattooing really begins with my first visit to his studio.

Mitsuaki Ohwada knelt on the tatami-mat flooring next to the prone body of a barebacked young man. Beside him was a rack of sixty steel needles, some highspeed and electric, others spliced into bone, ivory, or bamboo handles tightly fastened with silken threads, and a tray of colors, inks, vegetable dyes, and pigments. Scarcely shifting his gaze from the man's back, Ohwada made instant choices. He took the smallest needles to prick an outline in black Nara ink (*sumi*) that turned blue as it perforated the living flesh. His light staccato jabs produced holes so tiny you would need a magnifying glass to see them. Later, to shade the lines he would choose thicker points, sometimes clustering his jabbings in superimposed rows, and dipping the needles in different hues—Indian red that glows brown beneath the translucent surface of the skin, Prussian blue, yellow, green. "Red is dangerous," he said, explaining that it contains cadmium, a tin-white metallic element that is risky to the body but makes a tattoo shine. Dot by dot, micrometer by millimeter, an exquisite pattern began to emerge from the quick, deft punctures.

The client lay motionless, meditating, it seemed, to counteract the pain of the needle, although I understand that nowadays most inks are laced with cocaine to deaden some of the feeling. In the intense quiet of the studio, so remote from the atmosphere of a Western tattoo "parlor," I thought of Ohwada more like an artist brush-painting a landscape or an ikebana *sensei* carefully arranging flowers. Within an hour the session was over. A square inch of a man's body had been indelibly changed for life. Like fine Japanese calligraphy, a tattoo captures an instant for all eternity. There is no going back, no doing it over again, no erasing of someone's mistakes.

That brilliant afternoon in Yokohama was a true introduction to the Japanese art of *ire-zumi,* literally "insertion of ink," or more classically and elegantly *hori-mono,* meaning a thing "carved," "sculpted," or "engraved." I left Ohwada's studio that day fascinated by the profound paradoxes inherent in the art. Here was beauty created through brutal means. Power bestowed at the price of submission. Delicate elegance attained by way of violence. And, as I would come to see more clearly as I entered deeper into the tattoo symbology of Ohwada's art, the glorification of the flesh as a means to spirituality.

During the next three years, when I could get back to Japan, I took photographs of tattooed men, and some of the very few tattooed women. Increasingly I found myself compelled by the strangely contradictory aspects of irezumi, stumbling unwittingly into some vast system of omen lore. In ancient Chinese and Japanese necromancy, I learned that the alternation of yin (female) and yang (male) principles controls all human affairs. The simultaneous dualism

comprises opposing yet unifying forces of the universe where good and evil, heaven and earth, active and passive, light and dark all come to rest in balance and resolution. The reasons for a person to choose to be tattooed have been variously mooted by anthropologists, penologists, and psychiatrists: to entice good fortune or repel sickness and evil; to prove and display rank or status; to decorate oneself in an act of vanity or out of self-love. Now I was seeing firsthand the tattooer playing with combinations of belief, fact and fiction, transferring fleeting prayers into mortal permanence, disfiguring so as to adorn, and drawing equally from beauty and the grotesque. I saw the tattooee suffering abasement for some promised and supposed superiority, attaching himself to the superhuman by replicating on the canvas of his body the lures of faith, religion, legend, and popular—even vulgar—heroics and romance.

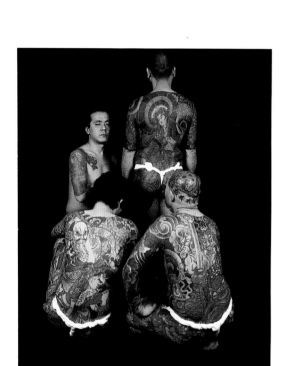

Of the hundred recognized practitioners of irezumi alive today in Japan, Mitsuaki Ohwada is perhaps the most skilled and knowledgeable. A number of examples of his work, some affixed to his own body, appear in the pages that follow. His professional name, and the signature he occasionally appends to his work since World War II, is Horikin, "carver of gold," to which he adds the dynastic number I. Traditionally when he retires or dies his son or favored disciple will assume the title Horikin II; however, in this case Ohwada's brother is Horikin II. The transmission of occupational cognomen hereditarily or to worthy apprentices has long been the custom in traditional Japanese arts and crafts—Kabuki or pottery making, for instance. Unlike some masters who traced their professional ancestry to the nineteenth-century trade guilds of **horishi** (tattoo experts), Horikin chose his own name with, of course, tacit approval from rivals in his field.

Horikin was born in the Year of the Rat, a zodiac sign from which he derives his "restlessness" and his "wealth." The rat while being a rodent and a pest is nevertheless depicted in Japanese iconography with "bales of rice," thereby becoming symbolic of abundance and fertility. Horikin assumed his name at age twenty-four, again in the Year of the Rat. His father was a functionary, an instructor at the Police Academy in Yokohama, a member of the rising middle class that sprang into being after centuries of feudalism were destroyed by the Meiji Restoration of 1868 and the rapid Westernization of Japan. At the time, tattooists still belonged to the lower castes. They were barbers, street artisans, or carvers of the woodblocks used by **ukiyo-e** artists for their prints. They catered largely to the "naked trades," porters, palanquin bearers, ricksha coolies, gardeners, postmen, and firemen, whose work exposed them to the open air and for which they stripped down to near nudity. The flamboyant tattoos stratified and classified these laborers. To make matters worse for the reputation of the profession, all Japan had been scandalized in 1900 by the love suicide of Horicho I, Japan's most celebrated tattoo master. He had earlier gained considerable notoriety for his dragons, with which he embellished the forearms of a young English prince (later King George V) and a tsarevich (Nicholas II), both visiting Japan as midshipmen on goodwill naval tours. It seemed as if tattooing was doomed forever to cause scandal.

From his earliest years, Horikin's love for tattoos had to be concealed from the Ohwada family. At age fifteen he began studying the wooden bas-reliefs in temples and shrines, copying on paper their intricate outlines and closely observing their play of perspective and chiaroscuro. His first essays with needles were on skinlike surfaces, hams, sausages, and daikon radishes, and from there he learned control, how deeply to penetrate, where and when to space his perforations. He became adept at **hanebari,** the fluttering technique unique to Japan, where the needles feather in details and accents. Before long he was experimenting on himself, under his arms and inside his thighs, where he was sure his parents would not see the tattoos. When he reached his majority at age twenty, when all Japanese become adult, or **seinen,** he revealed his by then much-covered body.

The family was shocked, and his father resigned his government post in shame.

Most people who are heavily tattooed live encased and enclosed in the special, isolated world of irezumi, a realm even now notable for its clannishness. They form a *nakama* or closeknit group of companions shielded from outsiders. They keep to themselves and are linked to others by a defiant sense of outcaste camaraderie. They claim few intimate friends but boast of their nakama. In Horikin's special case, he not only has a group of fifty or so loyal adherents on whom he can call at any time for any reason but a very impressive roster of international friends and acquaintances, among them Leni Riefenstahl and Issey Miyake. However, the irezumi's life is filled with intense competitiveness. There is always the concern that another master may steal a secret color or pattern or needle technique. They do not advertise. They are listed in no telephone book. Their fame rests on word of mouth, but acquaintances decline to give their addresses. "Tattoo is a territory," Horikin says, "a restricted territory."

Horikin enjoys reminiscing about the good old days. He recalls a predecessor who had only one arm and worked the needles with the help of his foot, while his wife pinned the writhing client to the floor. He remembers the first man to have his head tattooed, Horikame ("carved turtle"), who died in 1932. Crowds parted as he walked down the street, "like the Red Sea parting for Moses," he said. Now that Horikin's hair is thinning, he usually wears a hat in public to conceal his own tattooed head. He also laughs at the weaklings among his customers who cowered during the tattoo's excruciations. Only one out of a hundred clients who have asked him to tattoo their entire bodies have actually lasted to the end. He estimates that of the approximately twenty thousand Japanese today who have half tattoos, no more than a total of two hundred will go on to full-body tattoos. The fact that such complete tattoos cost thousands upon thousands of yen, and demand anywhere from two to ten years to complete are not the only deterrents.

Horikin also tells with amusement of clients who have asked for full tattoos and run out of the studio before he could finish "a dragon's single whisker." Another fainted at the first drop of blood, despite Horikin's assurances he had never, unlike some of his competitors, sent anyone to the hospital emergency room. Still another client became so befuddled after a two-hour session he forgot he was on the second floor and tumbled down the stairs.

In irezumi as in the warrior's *bushido* an unuttered code prevails. Horikin never touches needle to flesh without at least a week's prior discussions as to pattern, placement, purpose, and desire. He tattoos no one for whom he has little empathy, regardless of the amount of money proffered. Similarly, he will tattoo free of charge if someone pleases him. A curious relationship develops between tattooist and his subject, and the mystery of this is respected.

In my talks with Horikin more paradoxes surfaced. "Tattoo increases the good life," it is agreed. Yet, at the same time no one denies that tattooing shortens the life span. This is particularly true of people whose entire body is lacerated. Too little free skin is left to perspire or "breathe." Whatever the reasons for tattoos, such as beauty, health, strength, wisdom, wealth, and invincibility, longevity for the tattooee seems beyond the asking. Horikin shrugs and says, "You never really perfect your life's work anyway. . . . There's always some new place to tattoo, but man dies before his work is finished."

Horikin is indeed a man of many parts, rooted in the past and yet thoroughly modern. An enthusiast of blues music, he has one of the finest collections of rare *ukiyo-e* prints in the country. From them he has taken inspiration for many of his repertoire of some five thousand large and small tattoo patterns. Each tattooist inevitably puts his own individual stamp on designs as well as his methods of application of the images. Horikin knows these intimately. He is frequently summoned by the Metropolitan Police of Tokyo to help identify bodies. If there is a tattoo, no matter how small, his experienced eye recognizes the tattooist.

From that slender clue forensic detectives decipher the rest. Perhaps after all, Horikin's father is pleased with his son.

The clients themselves are paradoxes: most are men who are outwardly gentle, often lonely, eager to meet and impress women. Even those irezumi with rumored connections to crime and the underworld present themselves as courtly, shy individuals, proud of their tattoos that depict fierce warriors and legendary heroes. The irezumi simultaneously celebrate and conceal their sexuality, flaunt and deny their masculinity. The tattoos change, too, as the body moves, sometimes appearing playful and entertaining, sometimes grotesque and intimidating. Despite the fiery subject matter, the tattoo is cool to the touch, belying the brutal treatment it receives as it comes into being. I could not help thinking that such stoic endurance of pain sometimes masks social and personal insecurity. More than adornment, the tattoo becomes a client's armor against the outside world.

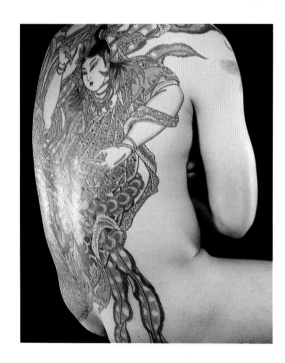

Of course there is a homosexual element among some of the irezumi, but this subject is taboo and not openly discussed. There are also construction workers and truck drivers who spend all their wages and most of their off-hours getting tattooed. They may be moved to display their "works of art" in a drunken moment in a Ginza bar, as might geisha or bar hostesses who bear a timid cherry petal on an inner arm or an autumn leaf above a breast as souvenirs of past loves. If tattooed men marry, they marry a woman who is attracted to the power and the strangeness of the tattoo as much as to the man himself. In fact, the wives of tattoo masters usually become irezumi themselves. ".Normal women don't like tattooed men," Ohwada says—although they are considered seductive, and myth holds that no woman ever refuses an irezumi.

Nothing has damaged the irezumi reputation more than its putative association with gangsters, the *Yakuza.* While largely rumor and partly reality, this questionable layer of society for a century now has had both the "time, money and need for group identification," as scholar John E. Thayer III observes, making them ideal clients for the tattoo artist. Somewhat equivalent to the Cosa Nostra or Mafia in the West, with whom they are now reputed to have dealings, today's Yakuza constitute some two thousand criminal organizations with an overall membership of one hundred thousand persons.

The word Ya-ku-za (8-9-3) comes from a gambler's card game in which that combination of numbers is "worthless." Like some of our prison inmates who tattoo the words "Born to Lose" on their biceps, Yakuza take pride in being worthless or useless members of an outcast social group. They trace their origin back to the seventeenth-century Banzuin Chobei, a commoner hero bandit immortalized in several Kabuki plays and, it might be added, in many portraits tattooed by irezumi artists. Now far removed from Chobei, originally a sort of Robin Hood, the Yakuza are deeply involved in prostitution, pornography, extortion, and drugs, with an income estimated by Japanese police at five billion dollars annually. Anywhere from sixty to seventy percent of its members are tattooed, and thus a fear of being taken for a Yakuza if one gets tattooed has spread into the hearts of ordinary Japanese. The U.S. Immigration and Naturalization Service, in an effort to alert our agents to Yakuza trying to launder money in America, devotes a section to tattoos in its 1985 manual, "Strategic Assessment: Asian Organized Crime."

Nonetheless, the stigmatic connection between Yakuza and irezumi has somewhat faded recently. Young Japanese are less afraid than their elders, who were suckled on Yakuza tales, for they have fed more on the *manga* comic books that so horrify Westerners by their violence and sexuality. Japanese who read these with nonchalance are likely to ask tattoo masters to apply violent imagery, sadomasochistic scenes, and *kappa,* the wicked river imps who traditionally drown children and rape women who venture near the water. Young Japanese also ask for *nukibori,* American style tattooing with its New York colors and

shadingless lack of subtlety ("cartoonish" to conservative Japanese eyes). Undoubtedly they have been influenced by the sixty thousand U.S. troops permanently stationed on Army, Air, and Navy bases in Japan, as well as the continual influx and outflow of military personnel who come on leave to Japan for R and R (rest and recuperation) from Korea, Okinawa, Taiwan, and the Philippines, and who take back home tattoo souvenirs of Japan.

For as long as recorded history, tattooing has suffered the unpredictability and trendishness of fashion, running the sometimes reasonable, often capricious gauntlet between sanction and sanctions. As early as 2000 B.C., tattooing was practiced in Egypt, according to evidence found in mummies. Ancient Greeks branded their slaves *(doulos)* with a delta, and Romans stamped the foreheads of gladiators, convicted criminals sentenced to the arena, for easy identification. Julius Caesar, when he invaded Britain in 54 B.C., noted with astonishment that the natives not only painted their faces with yellow weld, but wore more lasting decorations that were pricked into their skin.

As for Japan, the earliest chronicle written by Chinese, in A.D. 238–247, describes Japan as the "Queen Country" and recounts along with amounts of tribute how Empress Pimiko asked Silla (Korea) and Wei (China) for help in subduing her rival kingdoms. The Chinese scribes also remarked with some alarm that "the men both great and small tattoo their faces and work designs upon their bodies," a practice that for centuries would be absent from China itself. In Japan's own first historical record, *Nihongi,* compiled in A.D. 720, mention is made of an emperor who commutes his cook's death sentence to ostracism by "facial tattoo." It was not until the Edo period of the eighteenth century, a time of social unrest against the warrior caste, when the basis of the economy changed from rice to gold and merchants began surpassing their hierarchal superiors in extravagance, that tattooing began to be in vogue. While commoners were still at the lower end of the social ladder and politically oppressed, they were given freedom to pursue pleasures. Townsmen outdid the samurai in bravado and bravura. Along with the geisha's floating world of flowers and willows, and the arts of literature, puppet theater, Kabuki, and *ukiyo-e,* bathhouses and licensed quarters flourished. And so did tattooing. Courtesans tattooed *kisho bori* (promise engravings) on hidden parts of their bodies, visible only when naked or in the act of love. The men tattooed themselves more visibly as part of the bluster of being "chivalrous commoners." The variety and prevalence of tattoos is well documented in the popular picture prints of the day by Utamaro, Toyokuni, Kunisada, Sharaku, and Hiroshige, so highly prized by art connoisseurs everywhere.

An event of considerable significance to both Japanese culture and the evolution of the tattoo arts took place in 1805. Bakin, the preeminent novelist of Edo, published his translation of a fourteenth-century Chinese cycle of tales based on historical fact. *Suikoden* ("The Water Margin," or, as translated in Sino English by Pearl Buck, "All Men Are Brothers") was written just as the hundred-year-long Mongol dynasty of Yuan (when tattooing was introduced to China) was yielding to the indigenous Ming dynasty. *Suikoden* unfolds the heroics of Sung Chiang (whose chest was tattooed with an indigo leopard) and his band of thirty-six major and seventy-two lesser *hao han* bravos, or "men to be feared." Seventeen of them sported outrageous tattoos, and although they were good and generous men they had been driven to live outside the law by the wicked injustices of men in power. To serve the common good they retrieved ill-gotten wealth accumulated by officials. To take such treasure, to eat the fruits of misdeeds against the people, to spend a day in such riches meant to them "a smile in the next world." They marauded and swashbuckled, dyed their flags in human blood, and lit their lamps at night with oil squeezed from the fat of their victims' brains. They swore allegiance, took oaths of brotherhood that bound them to go through fire, to step into boiling cauldrons, and to live and die together for

one another. As if inspired by Thucydides they followed the dictum that "the strong do as they will, the weak as they must." Whatever their crimes they still righted wrongs, protected the young, and respected the aged. To beg pardon they bared their tattooed backs to be beaten.

The effect on Japan of *Suikoden* was electric. Kabuki adapted some of the stories, and the *ukiyo-e* artists illustrated all of them. Kuniyoshi, who had been a failure at his souvenir portraits of favorite actors and scenes of daily life that other artists issued in the tens of thousands (so that the populace could keep up with the latest rages), became an overnight sensation with his series, "108 Heroes of *Suikoden*." Bakin's book and Kuniyoshi's prints set the fashion for and established the canons of the art of tattoo that have lasted down through to the present.

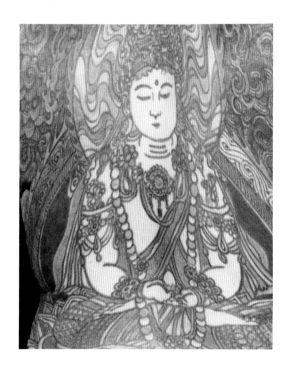

After the Revolution of 1868, euphemistically known as the Meiji Restoration, the face of Japan changed with the overthrow of the ruling military shoguns and the establishment of the emperor as head of state. The Englishman A. D. Mitford, later Lord Redesdale, one of the earliest chroniclers of this turning point in Japan's history, arrived as a junior official with the nascent embassy in 1866. Moved to describe the turbulence of the times, he attended a public crucifixion, was invited to a *seppuku* (harakiri), and watched the *eijanaika*, a superstitious dance craze that seized the country and was performed daily to celebrate "the end of the world." He also met the last shogun, Tokugawa Keiki, soon to be deposed. Mitford was present when the Emperor Meiji met for the first time with foreigners. "As we entered the Son of Heaven rose and acknowledged our bows. He was a tall youth with bright eyes and clear complexion. His eyebrows were shaved off and painted in high up on the forehead; his cheeks were rouged and his lips painted with red and gold. His teeth were blackened. . . ." To the English this was grotesque, "a travesty of nature."

Japan was acutely sensitive to the opinions and the taste of foreigners. It was only after Japanese ambassadors abroad reported on being taken to the opera as an honor for dignitaries that an emperor of Japan was allowed to attend a Kabuki performance. Until 1887 it had been considered "common," like tattooing. As for tattooing, in 1869 the Japanese were so fearful of appearing barbarous in Western eyes, or rendering the nation contemptible to Americans and Europeans, that tattooing was summarily interdicted. (So was the Buddhist ceremony of cremation.) The police raided the mansions of tattoo masters, seized their paraphernalia, and destroyed their "pattern books." However, the inscrutable Westerners were baffling to the Japanese. They were fascinated by Japan's tattoos, with embassies invariably choosing the most totally tattooed grooms to pull their rickshas. In time the Japanese government relented, and tattoo master Horicho's establishment was permitted to reopen in Yokohama with a sign, "For Foreigners Only." This was where those young sailors George and Nicholas went fresh off their ships.

It is impossible to discuss irezumi without touching on the great classical theater of Kabuki. It has served as Japan's most profound and verisimilar source of the nation's "living history" and teems with dramas where plot devolves on tattoos and ensuant revelations. These include, inevitably, *Suikoden* tales, but also many more created originally by Japanese playwrights. Grand Kabuki, on its most recent tour in 1985 at the Metropolitan Opera House and Kennedy Center in Washington, surprised Americans with the starring performances of *The Scarlet Princess of Edo* by Takao I and Tamasaburo V. Both the male and female leading roles require tattoos. The hero Gonsuke is a scoundrel, by profession a gravedigger. He is also a thief and an assassin for hire, but, of course, with a heart of gold. On his forearm is a large tattoo of a metallic blue temple bell, a talisman, suspended from a sprig of cherry blossoms. The heroine Sakura, or "Cherry," is a virgin princess with the soul of a whore. In the middle of the night Gonsuke robs her palace, but as he is making his escape he sees the sixteen-year-old sleeping

beauty, the princess, and not wanting to miss an opportunity rapes her. She is unable to see his face, but, "in the pale morning light of dawn's crescent moon," she says, "I caught one glimpse of that arm. Oh! Mark of manhood!"

A year passes, and the princess is about to enter a nunnery. Gonsuke is entertaining Sakura's ladies-in-waiting with a ribald story when he lifts the sleeve of his kimono to emphasize a point. Sakura sees the tattoo, dismisses her retinue, and bids Gonsuke draw near. She pulls up her own sleeve and reveals the identical tattoo on the inside of her arm. She had undergone this pain as proof and pledge of her passion and, according to the power of tattoos as amulets, as magical assurance that she would meet him once again. Indeed, she does. "So, you were the one?" Gonsuke exlaims. "Pierced by love's arrow, within my body both my love and a child grew," she answers in a classically poetic stanza. They resume their love affair but do not live happily ever after. They join society's dregs, and live miserably but lovingly in Japan's lower depths. At the end of the play Gonsuke promises never to abandon her. He does not, but sells her to a house of prostitution so that they may live in comfort.

Since the Meiji period, irezumi with remarkable masterpieces tattooed by famous masters and with particular urges for immortality have willed their highly prized bodies to university laboratories, somewhat in the way Westerners donate organs for medical research or transplanting. More often, however, irezumi who have fallen onto hard times, or who are in urgent need of immediate cash, sell their bodies to institutions staffed by doctors specially trained in decortication. They remove the skin from the fresh cadaver in one piece, preserve it in oils, and mount it, eventually, in airtight frames, so that it can be sold to a museum or private collector. There are probably some three hundred of these half- and full-body tattoos in existence at present. I was given a special tour of the largest collection, one hundred specimens, lodged at Tokyo University's Pathology Department. Nowadays the legalities are considerably more complicated. Beyond the expressed wishes of the deceased, the consent of the entire immediate family must be given and official documents signed and sealed. Occasionally these items come up for auction, and one example of a half-body tattoo a few years ago went for fifty thousand dollars.

Contorting himself in front of mirrors or viewing a friend's snapshots had been the only visual access an irezumi had to the artwork carved into his own back. The almost life-size twenty- by twenty-four-inch instant Polaroid prints reproduced in this book provided a unique opportunity for each irezumi to scrutinize himself in a new way. They began to see themselves fully for the first time and, over a period of years, to reveal to me the depths of their culture, eventually exhibiting not only the beauty and charm but also the sinister, the macabre, and the perverse elements of the Japanese tattoo. The contradictions inherent in the art imbue the photographs with the power to seduce and repel. This is their magic.

THE
JAPANESE
TATTOO
THE PLATES

RESTRAINT The most ubiquitous of all mythological beasts in Japan is the dragon, which one encounters as ornament or decoration in all aspects of daily life. Symbolically it denotes wealth (the emperor's clothes are called "dragon robes"), and because it lives as easily in water as in air it protects from fire. The dragon is an all-powerful being, a "composite monster" that draws strengths from each of the creatures forming it. It is a serpent that has the horns of a deer, the scales of a carp, the four-clawed talons of an eagle, the nose of a goblin, and, inexplicably, whiskers and a mustache and flamelike appendages at shoulders and hips.

Tattoo master Horikin is best known for his Japanese style full-body tattoos. However, this client asked only for a single dragon, perhaps to celebrate his having been born in the Year of the Dragon, the fifth year of the Oriental Zodiac, or perhaps to "strengthen" his right arm. Moreover, he asked for *nukibori* or Western-style tattooing, recently popular in Japan among the young. In nukibori the outline of the pattern is filled in with solid color rather than the more characteristic shading and feathering of Japanese traditional methods.

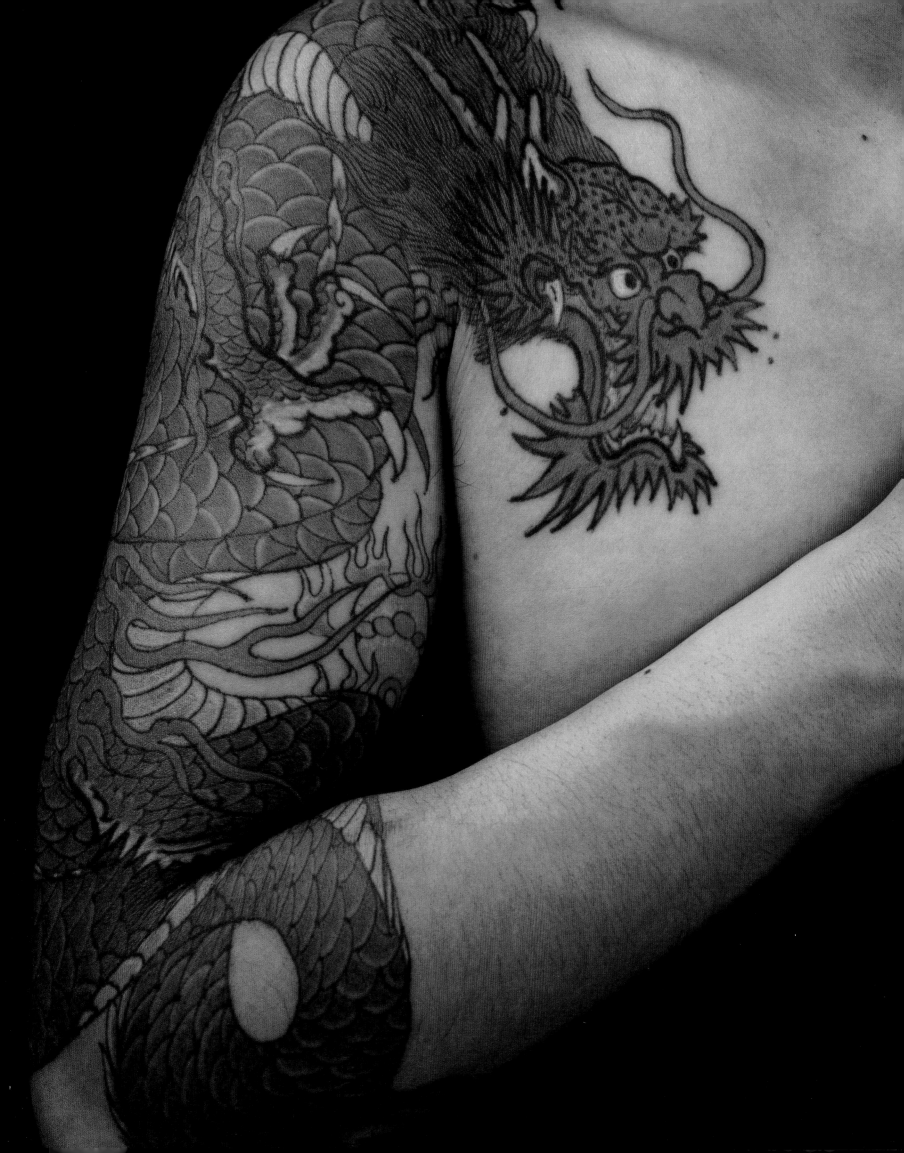

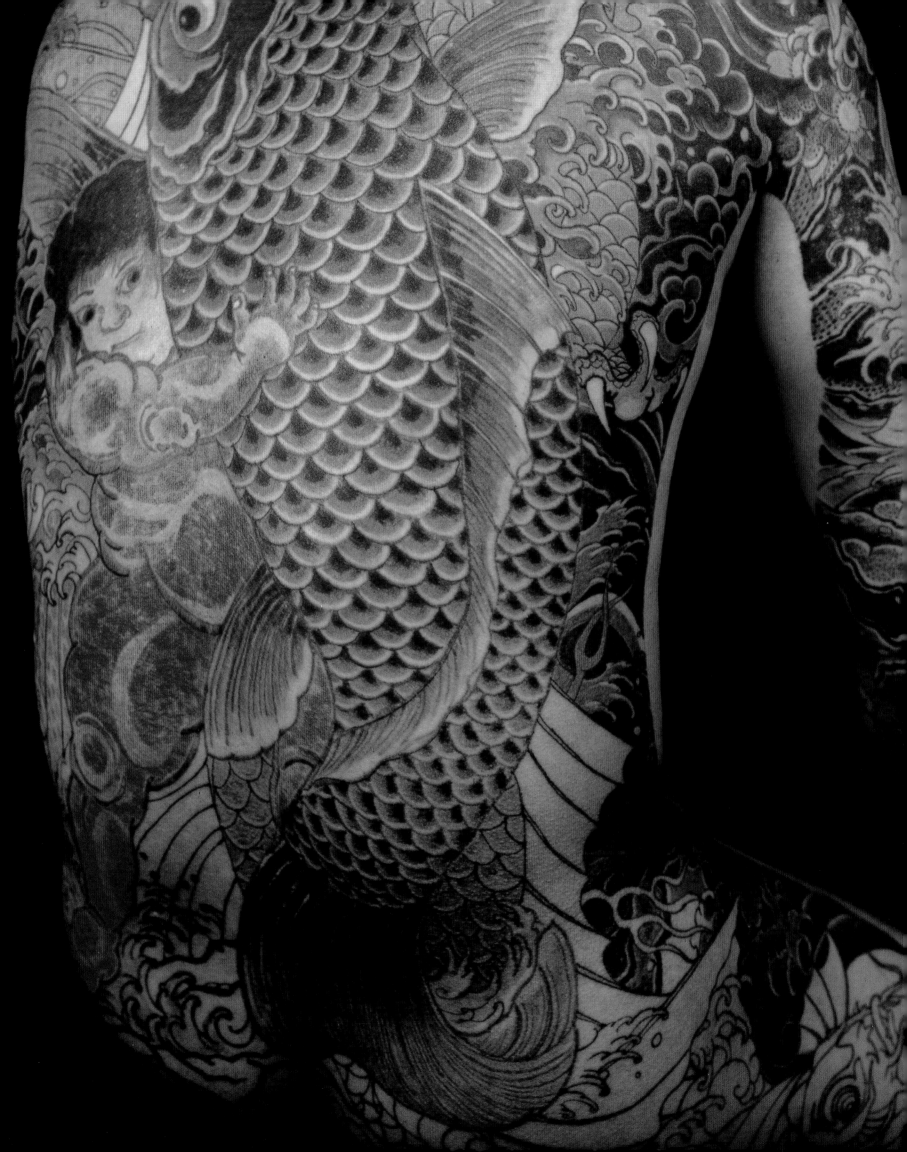

KINTARO Horikin here turns his attention to Kintaro (Golden Boy), one of the most popular characters in all Japanese folklore and fact, combining a local fertility god with an actual historical figure. Kintaro was a child, a sort of Superboy, whose prodigious feats of strength and perseverance have served as an ideal for a thousand years. Naked and red-complexioned, the child is depicted in art as fighting and subduing a giant carp. The legend of Kintaro is central to the celebration of Boy's Day each year on May 5. Families with sons fly paper streamers or cloth carp on tall poles outside their houses to symbolize their Kintaros within. The carp (*koi*) is King of the River Fish for eating. One ancient Chinese tale tells of how a brave carp leapt a waterfall and became a dragon. The carp when caught awaits the knife without flinching.

During the course of this project, the subject of this photograph became very ill. Horikin suggested to his client that he might one day bequeath his tattooed skin to the university museum. The man seemed willing, but his relatives objected. Because Japanese law prohibits preservation of the skin without approval by the person's family, this photograph will probably be the only document of this work of art.

RED KINTARO Another tattoo master, Horiyoshi II, covered his subject's entire back with the cherubic child Kintaro struggling with the mighty carp. Kintaro wears a blue *haramaki* stomach cloth to protect the *hara*, or belly, which in Japan is considered to be the source of emotions, thoughts, and intentions. It is the navel specifically to which the Thunder God is attracted in infants, soldiers, and the sick, causing ailments. Hence the protective, warming sash.

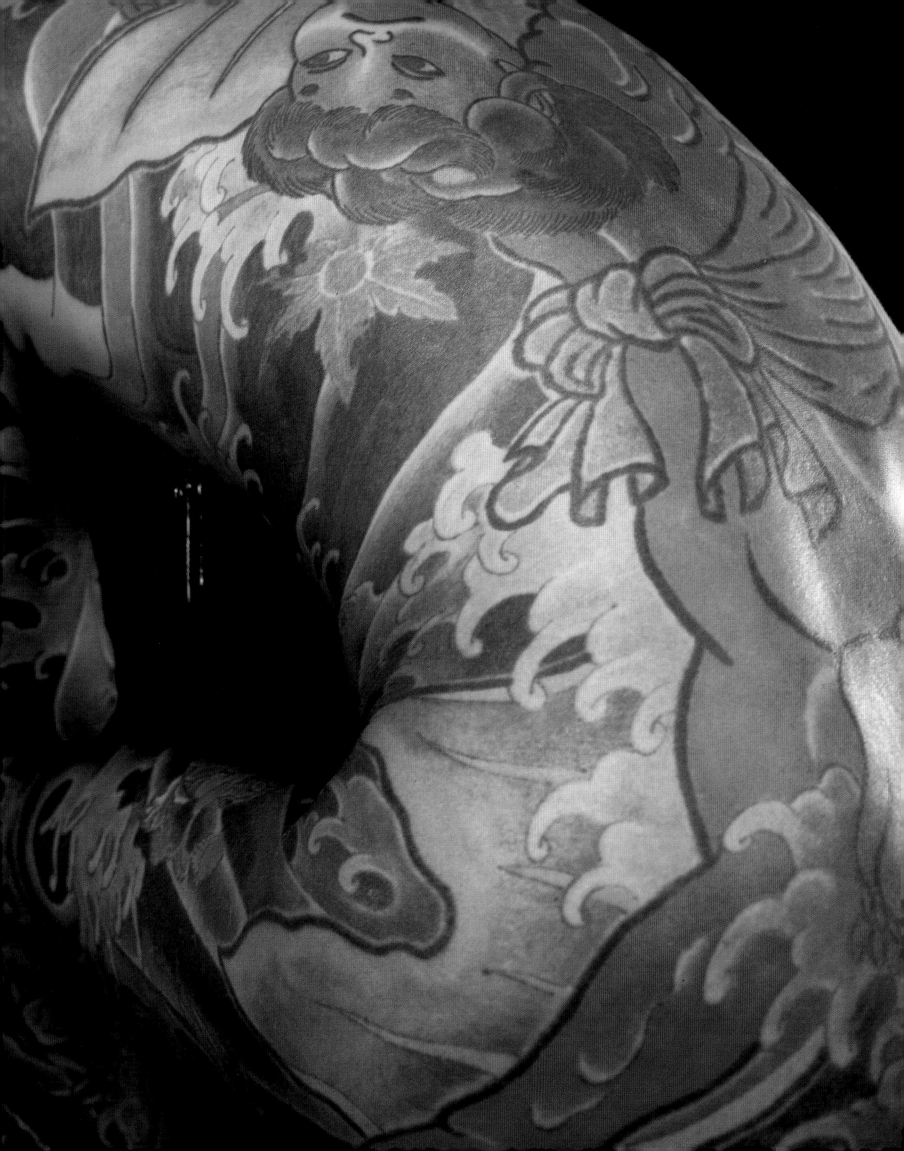

LION DOG When Empress Jingo in A.D. 200 invaded Korea, the king of Korea swore to defend the Imperial Palace of Japan in perpetuity. The mythical Korean dog (*koma inu*), here tattooed by Horigoro III, as well as the Chinese lion (*kara shishi*), whose statues in stone or porcelain you see outside Japanese shrines, graves, and even private mansions, have become symbolic of guardianship, the protectors of sanctuaries. Their fierceness (yang) is always contrasted with the gorgeous peony flower (yin) for esthetic balance. The skin of the head of the Korean dog was regarded as so tough that it was used for military helmets and considered impervious to arrows. The dog in general is also thought to be a loyal guardian of infants and children.

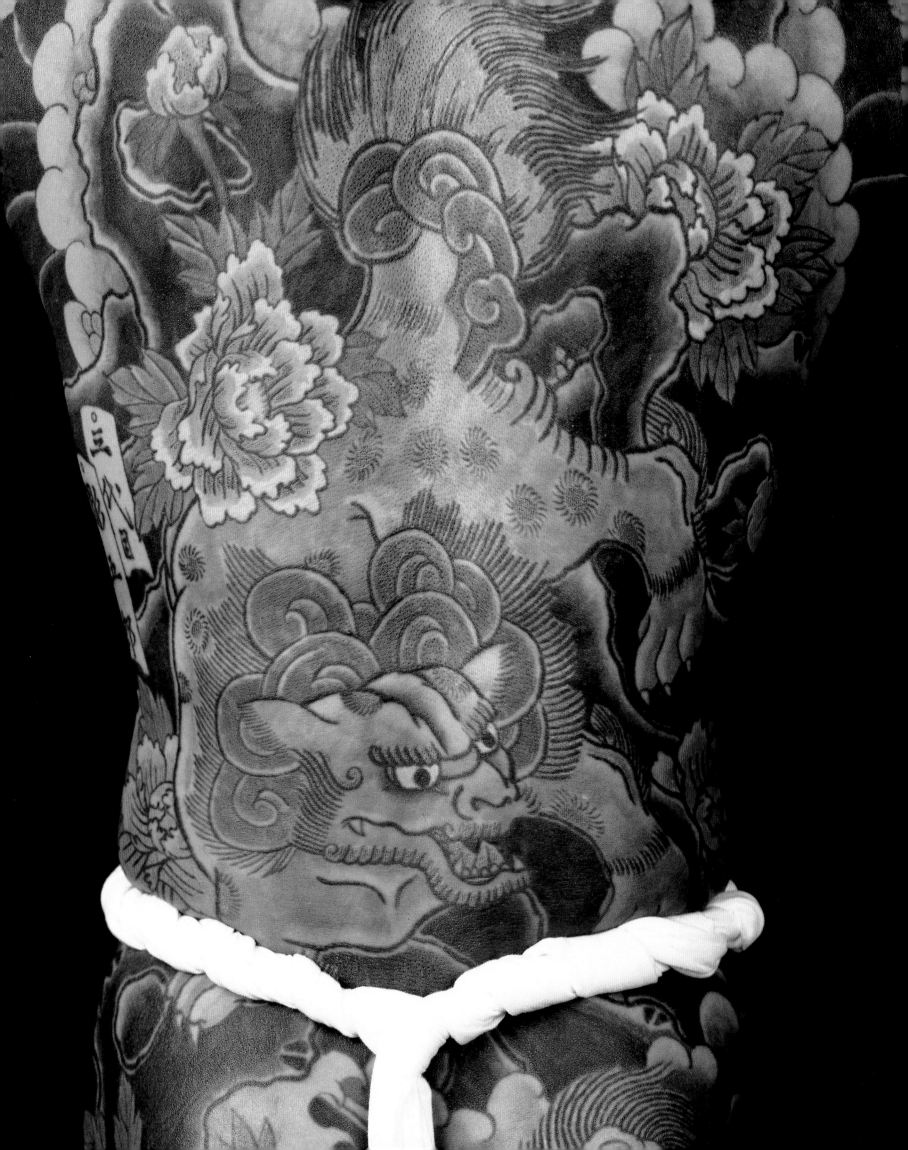

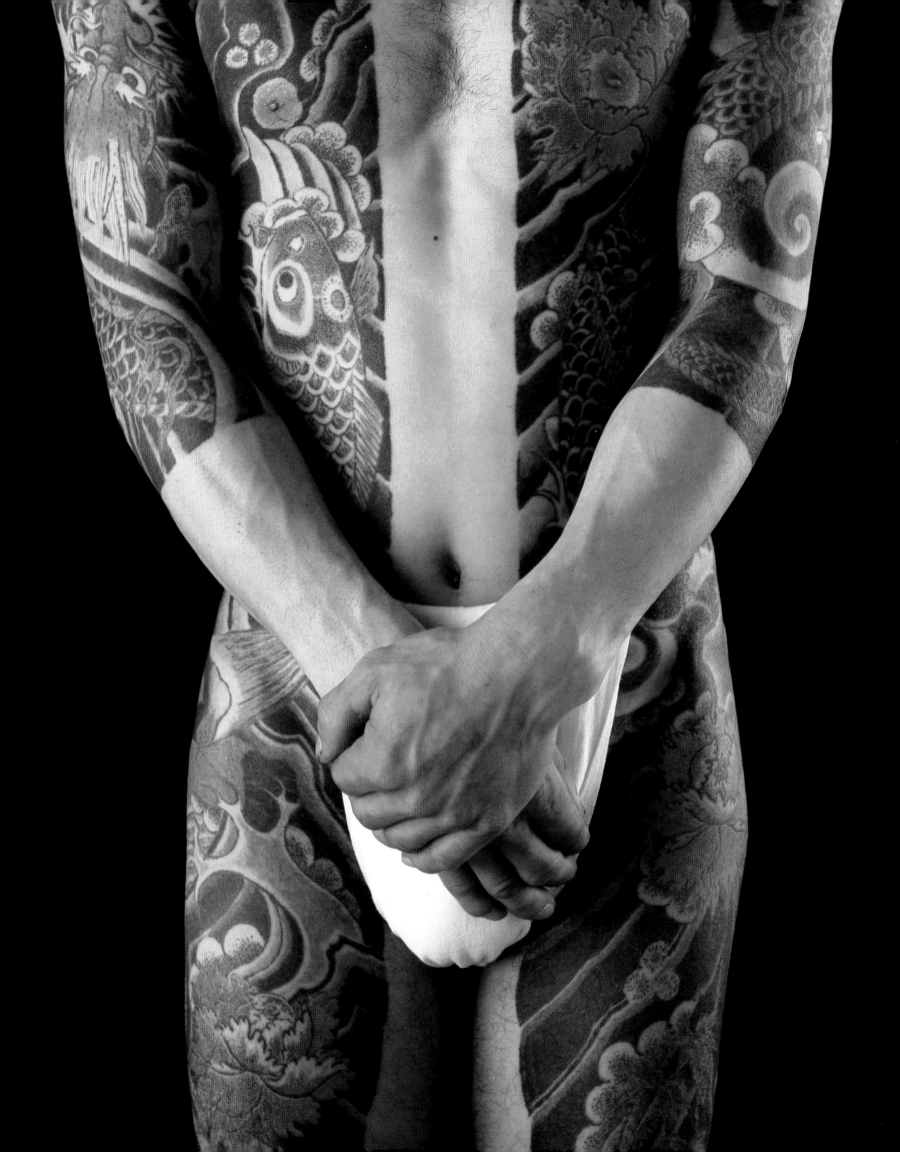

MODESTY One of the oldest tattoo styles still popular today, here executed by Horijin, is called "river" (*kawa*) after the river of clear skin down the chest. Because of its short sleeves and trousers that cut off just below the knees, the entire tattoo can be concealed by wearing a happi coat and mompei trousers. The "river tattoo" or "one-fourth body," as opposed to full-body tattoo, is also convenient for removal (flaying) after death without disturbing the irezumi overall patterns.

The left nipple is a peony while the right becomes the source of a waterfall that the carp climbs, persistently, in order to spawn. The right bicep boasts a horned dragon whose tail ends up in clouds on the left arm. The subject wears a *fundoshi* loin cloth, the usual underwear for Japanese men.

SEVEN GODS OF GOOD FORTUNE

The client's protruding abdomen suggested to tattoo master Horiyoshi III a design involving the Seven Deities of Good Fortune, widely worshiped by the merchant class of the seventeenth century, the time of tattoo's greatest fashion, and still popularly revered even today. Hotei, the bald-headed and enormously fat central figure, represents largeness of soul and inner wealth of resources. He was historically an eccentric Zen priest and an incarnation of the messiah of future bliss, the Maitreya or Miroku bodhisattva. The tattoo master has put this god distinguished by his large stomach on the large stomach of his client, so that he seems to be wearing his own self-portrait. Above Hotei in the tattoo is Jurojin, another of the good luck gods, and deity of longevity. This venerable old man always carries a holy staff to which is tied a scroll containing all the wisdom of the world. Wherever he goes he is accompanied by a crane, another symbol of longevity because long after the crane is lost to sight his voice in the sky can still be heard. On the left arm is a rendition of Kabuki makeup indicating a brave and angry commoner insulting samurai superiors and righting wrongs.

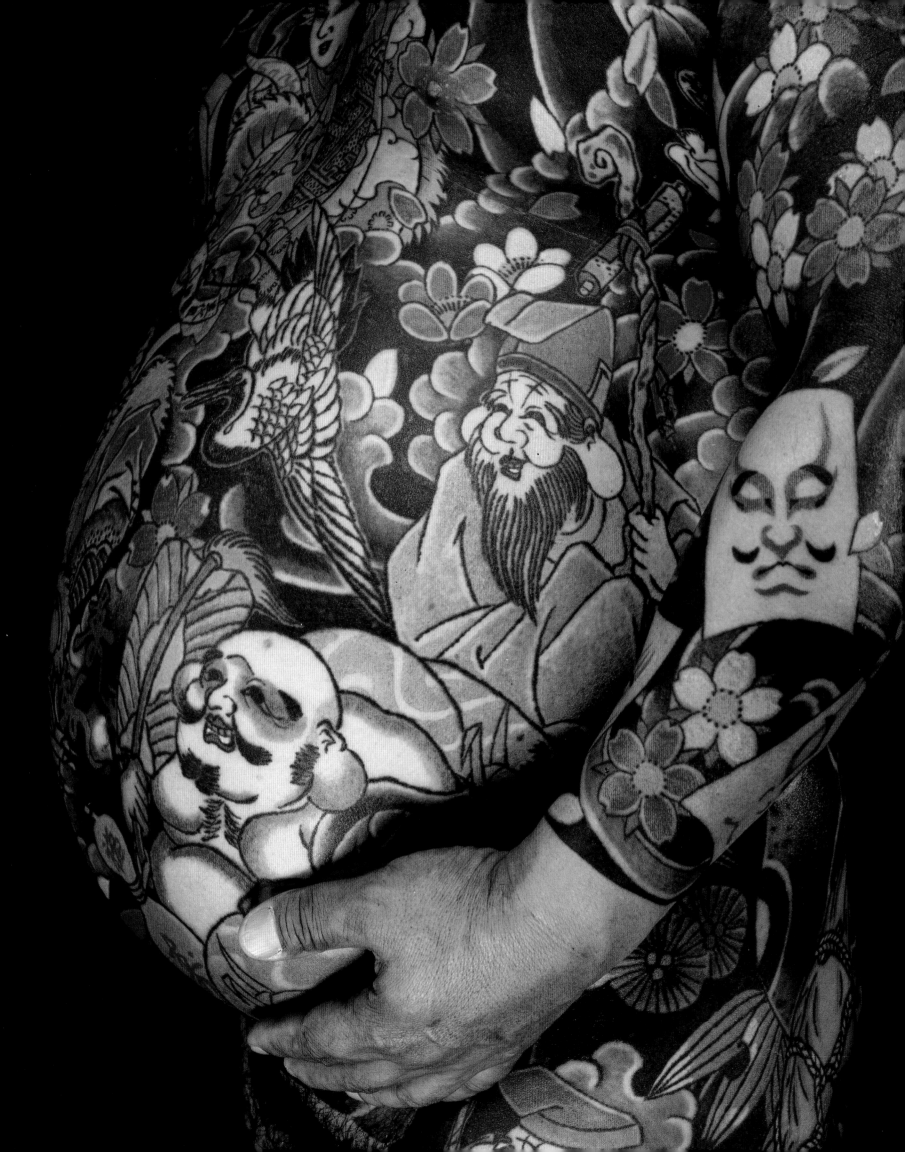

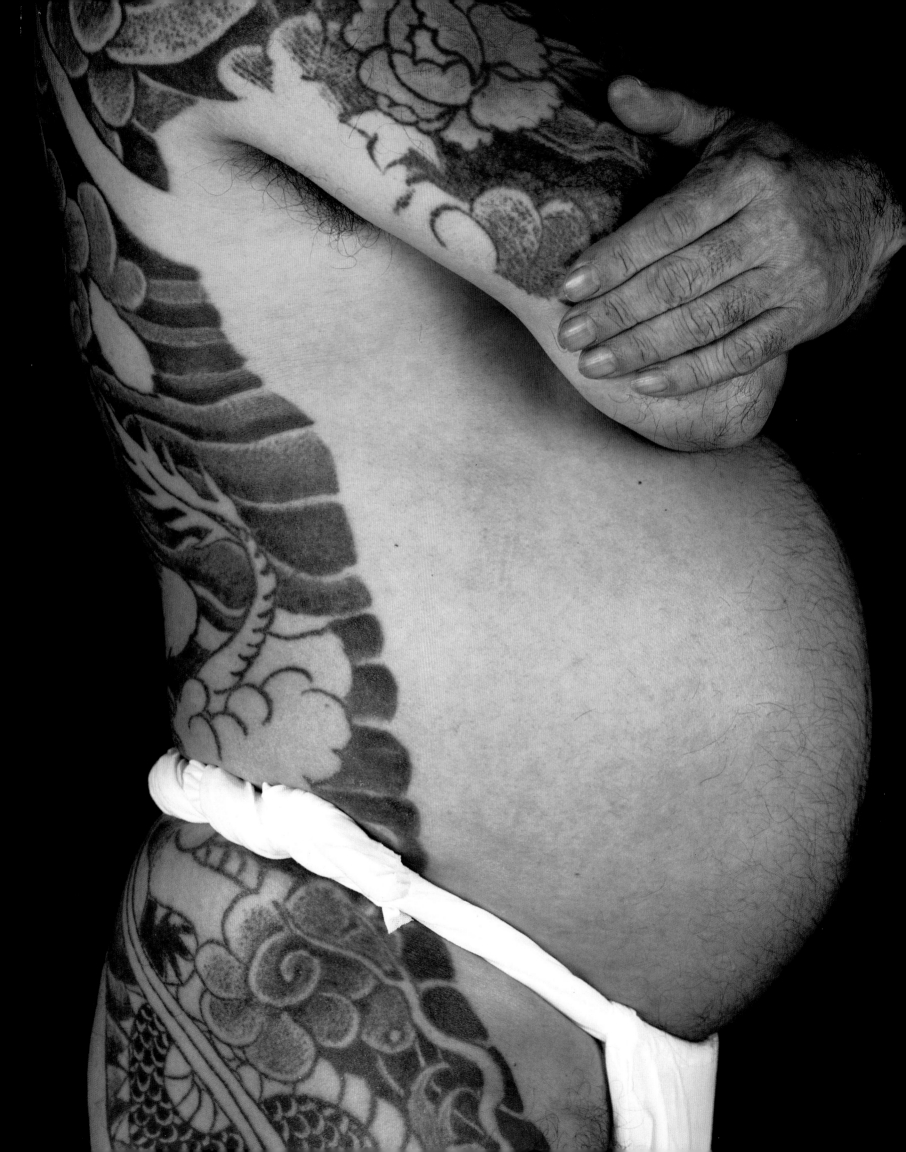

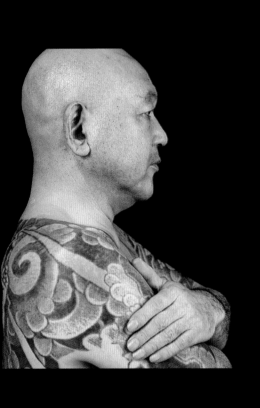

CENTER AND WISDOM This back tattoo is called *kame*, or tortoise, because it resembles the protective shell on the turtle's back. Again the belly, especially thrust out when posing for this photograph, represents wealth and absence of hardships. Horijin here is the subject and Horishiba the artist tattooer. Horijin started his professional life as a painter but turned to tattooing when he tired of drawing on paper's flat surfaces.

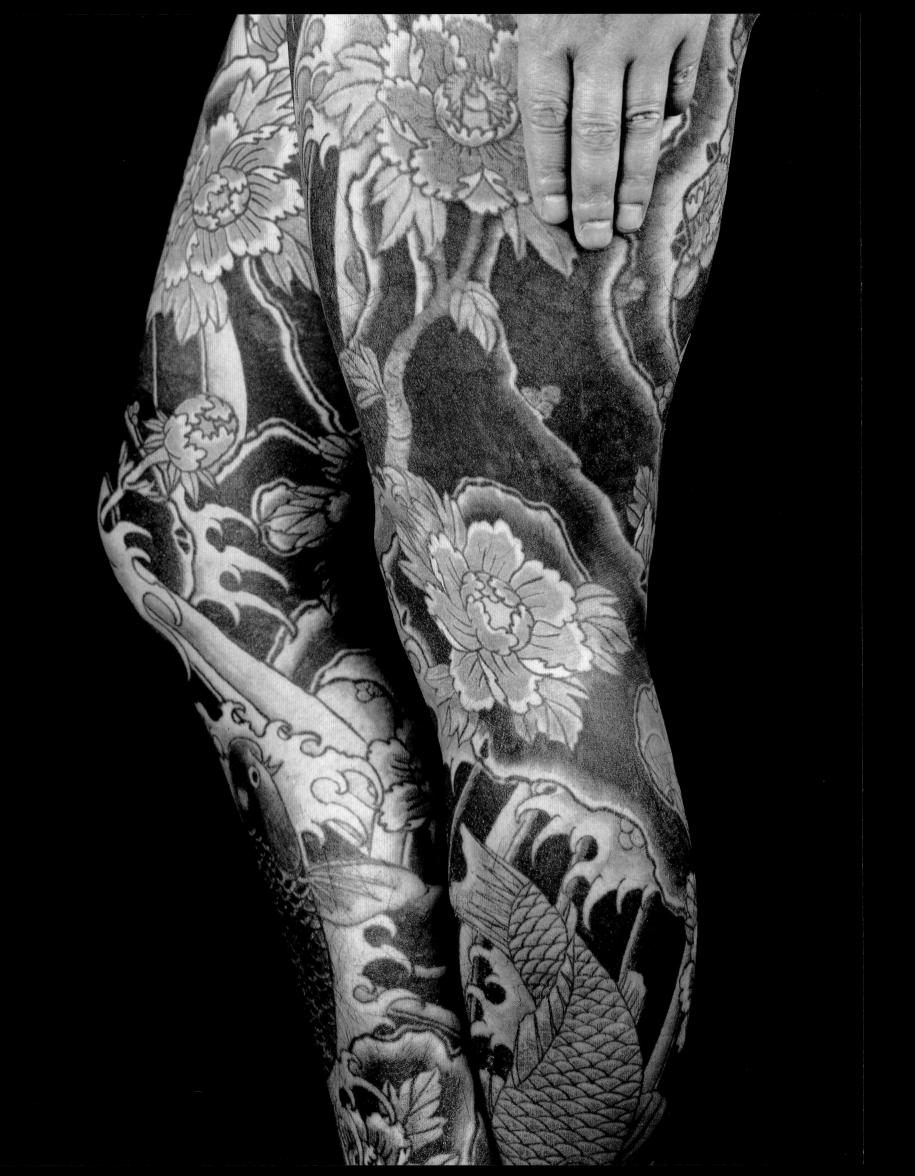

FLIRTATION The legs are enveloped in patterns of peonies, waves, carp, and the elusive, hard-to-catch catfish, done by both Horigoro II and Horigoro III. The model here was one of the first I photographed. He was gentle and kind, often hung about the studio idly, and was always soft-spoken. It was whispered that he had served eight years in prison for having killed someone in a knife fight. It was also said that he had cut off the last digit of his left-hand little finger in atonement for the life he had taken. However, the story was perhaps designed to disguise his membership in the Yakuza, a band who pledge loyalty in blood and frequently forfeit the joint of a finger to prove eternal fidelity.

FIRE AND WATER (overleaf) The two groups of legs were arranged casually but fell naturally into what the master called "a composition of yin and yang," opposites and resolutions, the ebb and flow that produces all change in the observable world. Flames and waves, dragon talons and carp, autumn leaves and clouds, tortoises and gods of luck with their bags stuffed full of worldly blessings.

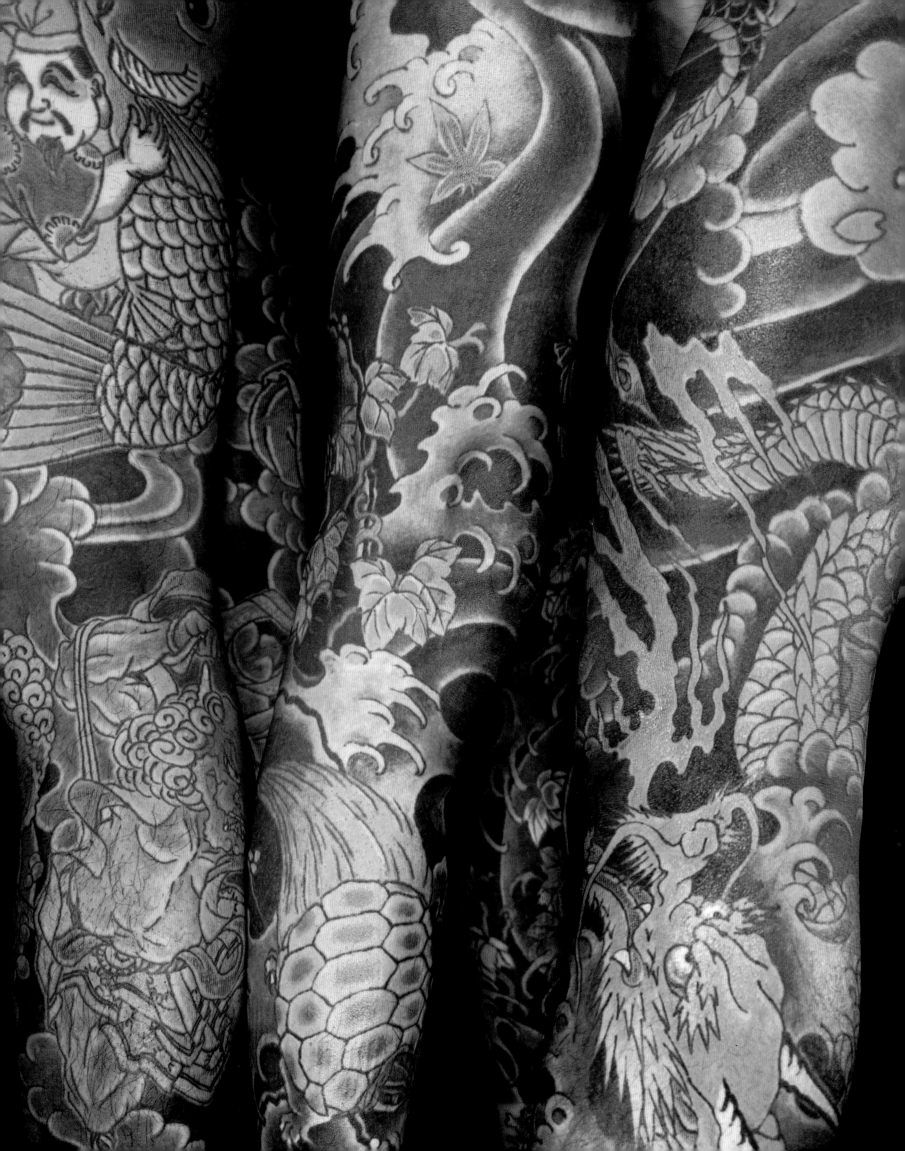

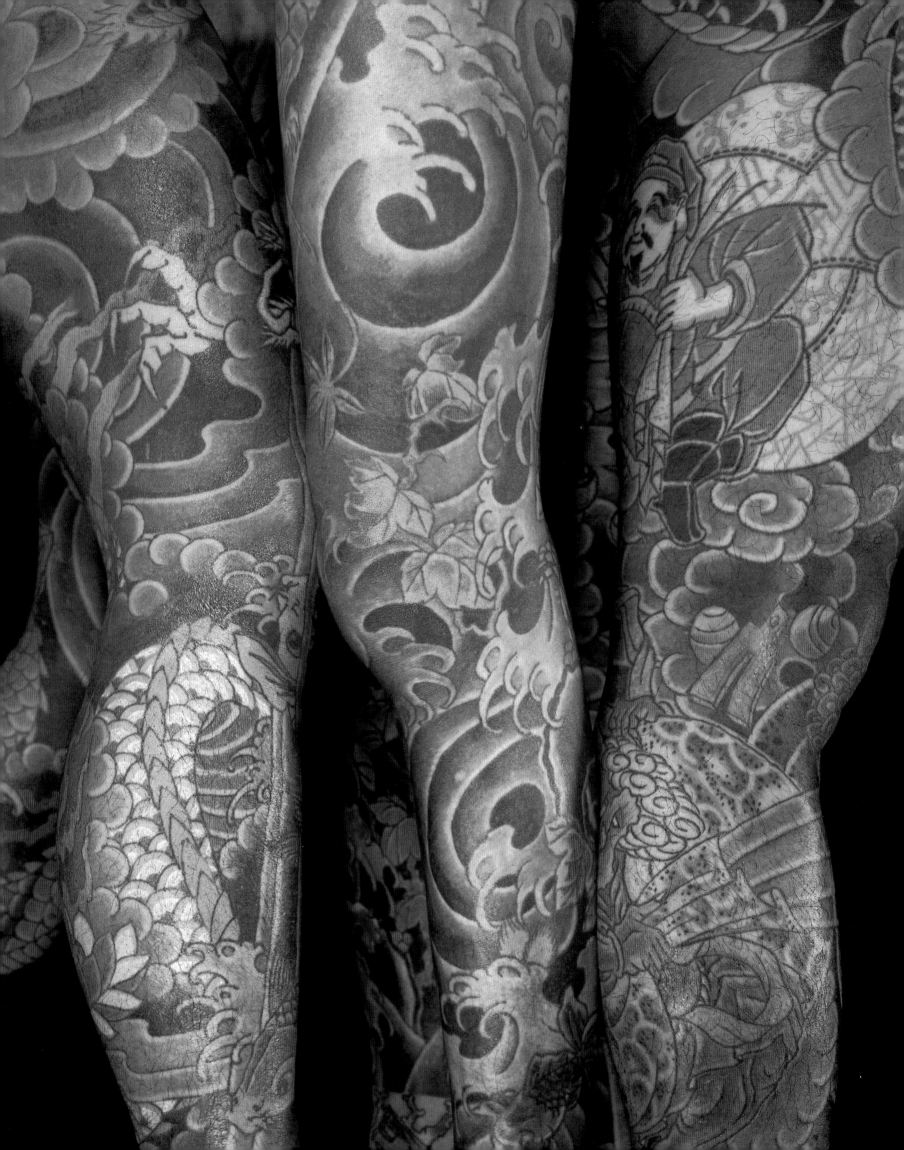

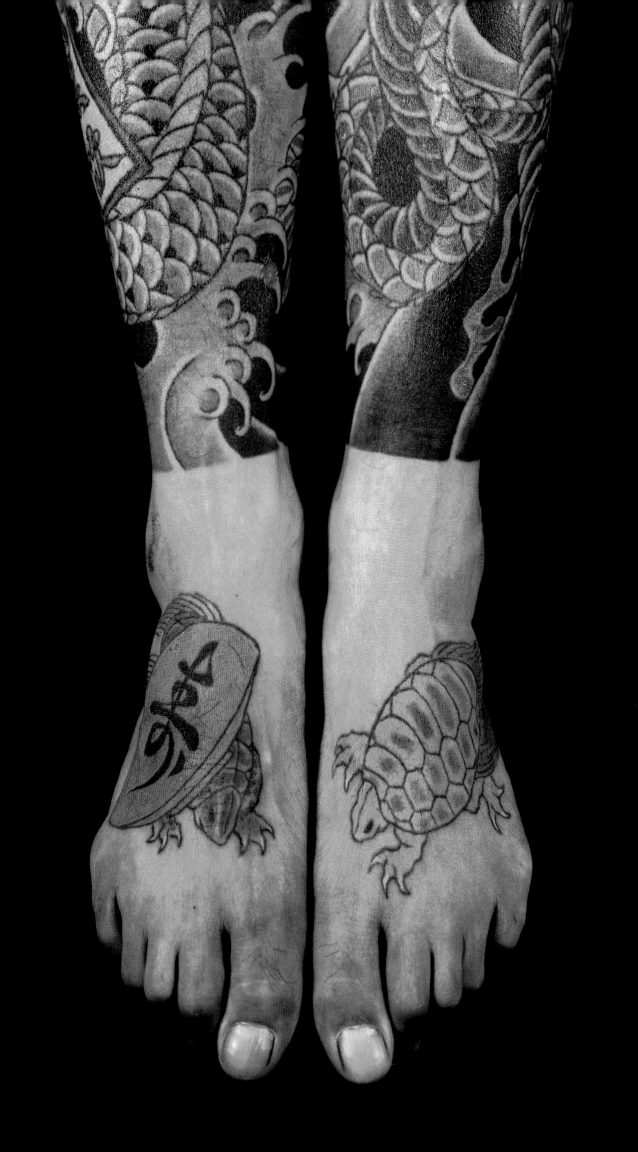

FELICITY The tortoise is a symbol of longevity since it is reputed to live "forever." It also carries with it sexual connotations because its extending and retracting neck resembles an uncircumcised penis. The subject shown here asked Horiyoshi III, somewhat unusually, to tattoo the top of his feet. The master chose the tortoise pattern and on the right foot added the *kotobuki* ideogram for "Congratulations" or "Felicity." The client also requested tattooed eyebrows, ostensibly to make his face more fearsome. Cosmetically he doubtless hoped his narrow eyes would appear larger.

HEIKURO AND SERPENT For this tattoo, Horikin turned for inspiration to Heikuro, one of the 108 tattooed heroes of the picaresque Chinese novel *Suikoden*. It was translated by Bakin in 1805 and glorified in the 1850s by *ukiyo-e* artists Utagawa, Kuniyoshi, Toyokuni, and Kunisada. Here Heikuro's battle to the death with a serpent is depicted so graphically that one feels the writhing serpent's power and Heikuro's valor with each movement of the tattooed body. The sinuous twists and turns of the serpent become indistinguishable from the irezumi's folds of skin.

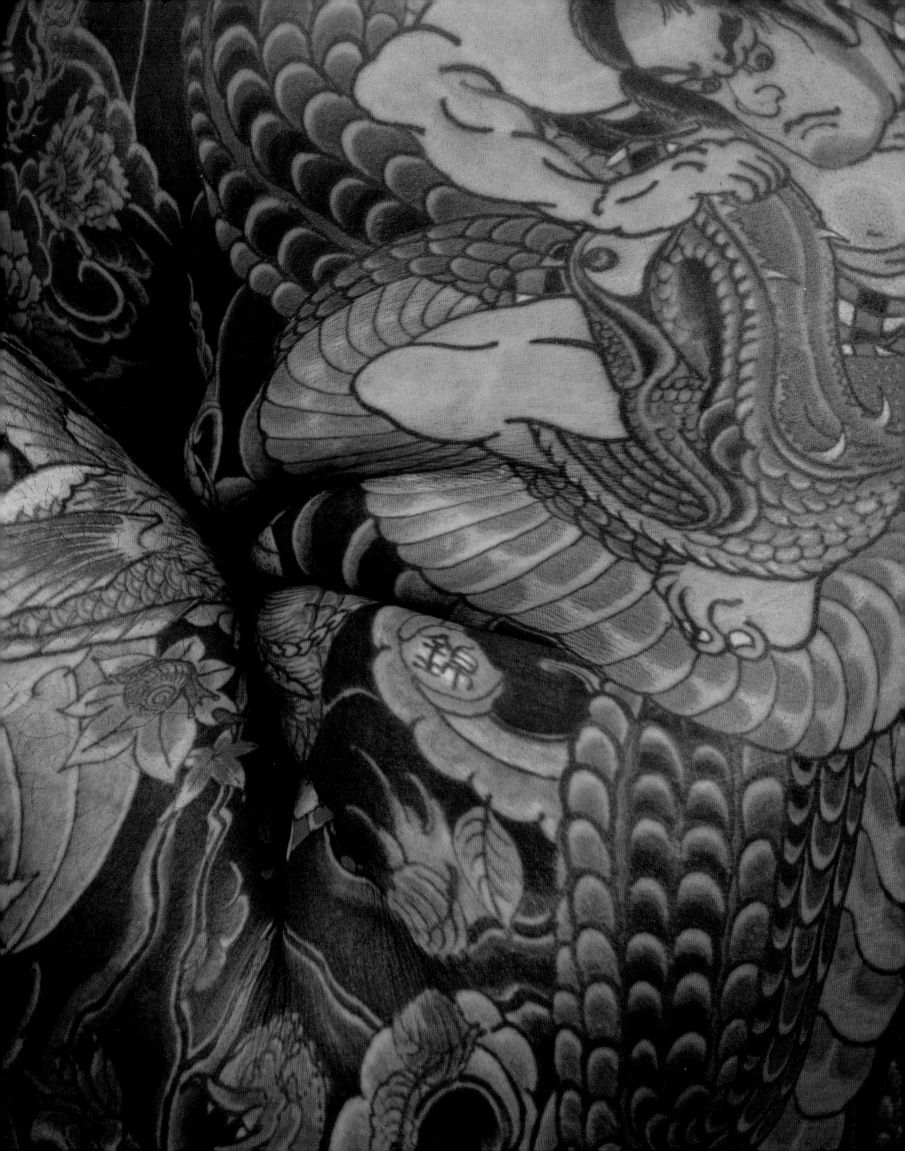

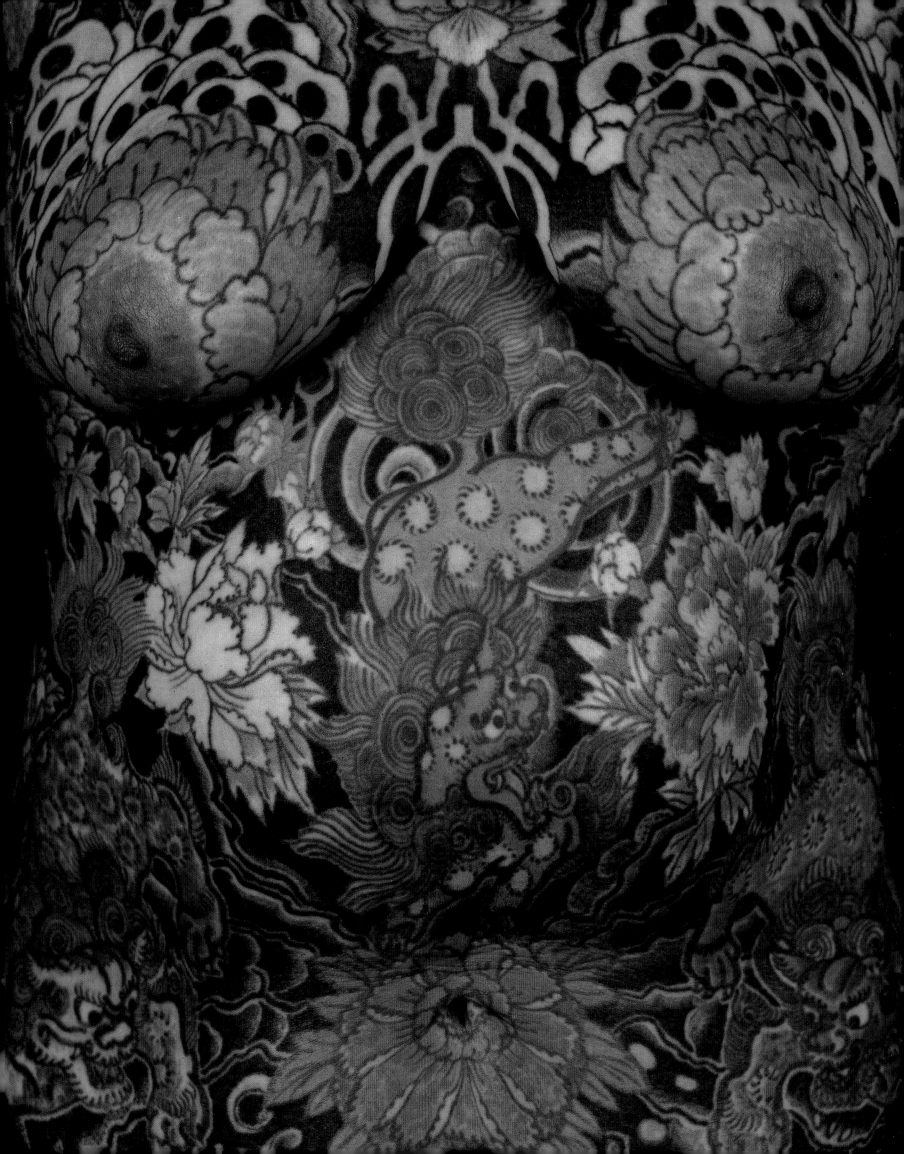

DARING Horikin practiced in his early years on his wife, experimenting with colors and techniques he would later perfect and become famous for. Her pale skin makes the colors particularly vibrant, and it is false modesty on his part to regard this early example of his work as "unsophisticated." Over the stomach, between the peony breasts and the peony navel, sits the all-powerful, all-protective Chinese lion, benevolent and kindly but a fierce defender, symbolic of courage and fortitude. Guardian Korean dogs adorn each hip and perhaps ensure fidelity or safety in childbirth. One macabre note: mounds of skulls rest atop the breasts. Overleaf: Detail of the peony navel and guardian Chinese lion.

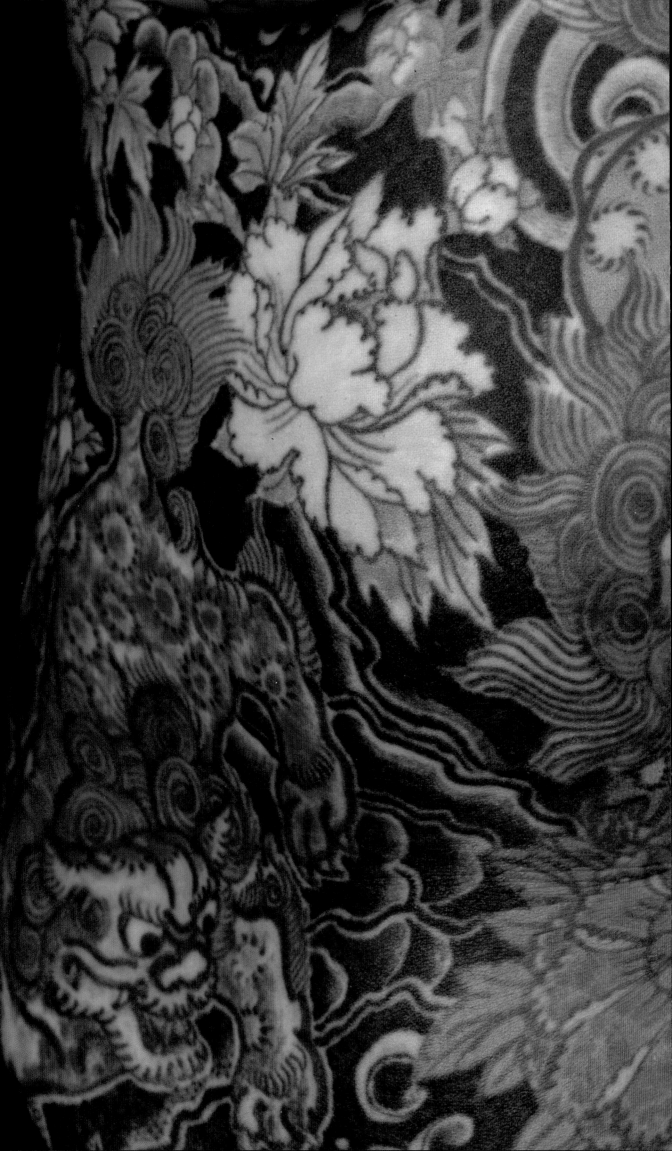

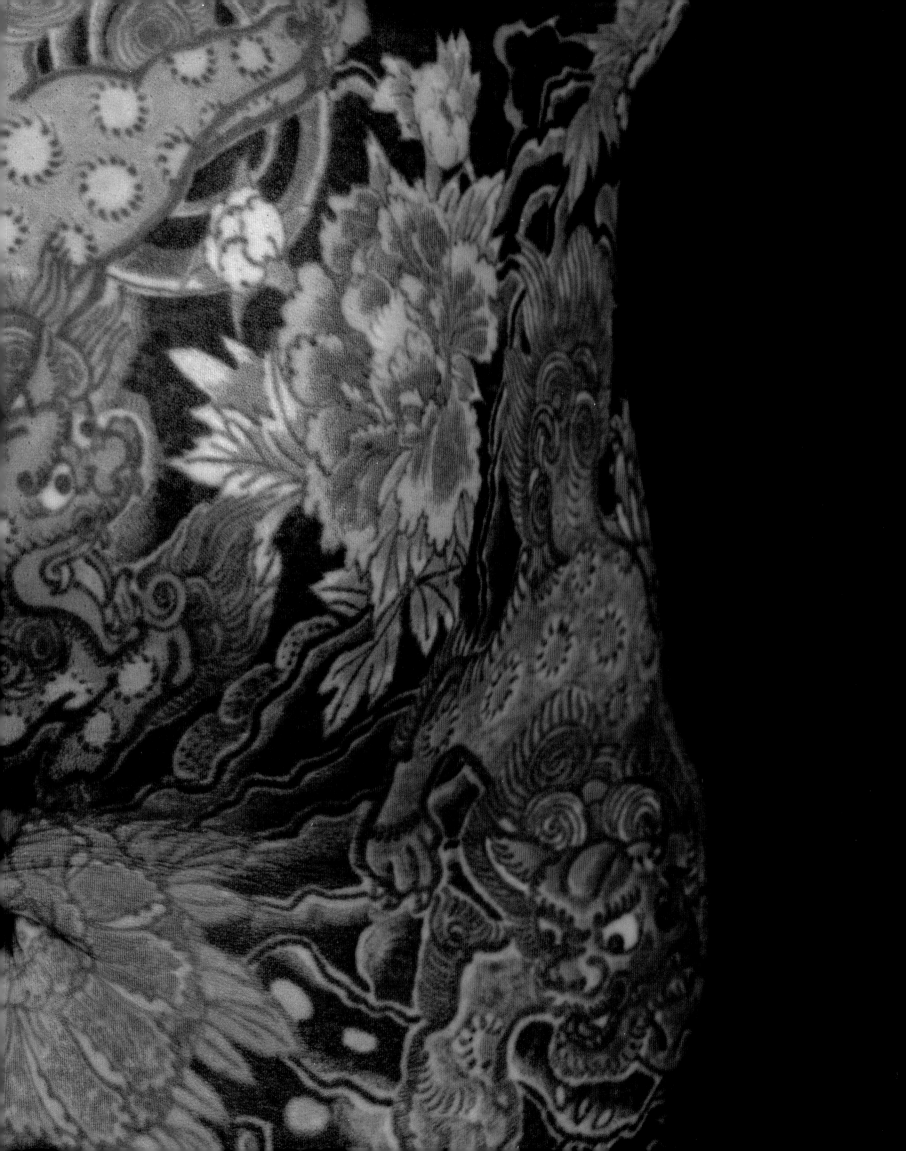

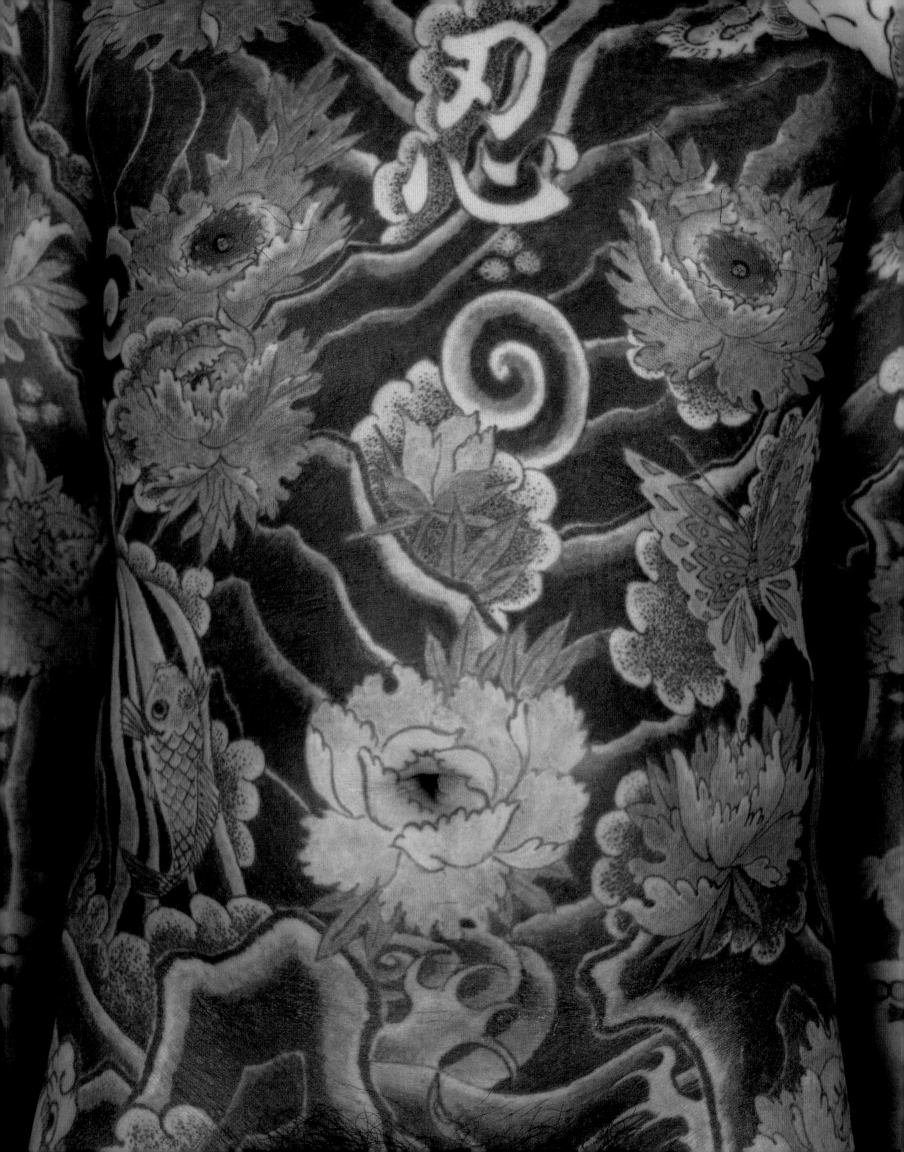

ENDURANCE Peony nipples and navel attract the butterfly as the waves and rocks draw the carp. Above the solar plexus Horijin has tattooed the virtuous character *shinobu*, meaning "endurance." This word has a subsidiary meaning also pertinent to the irezumi world, "to hide oneself" or "to live in concealment."

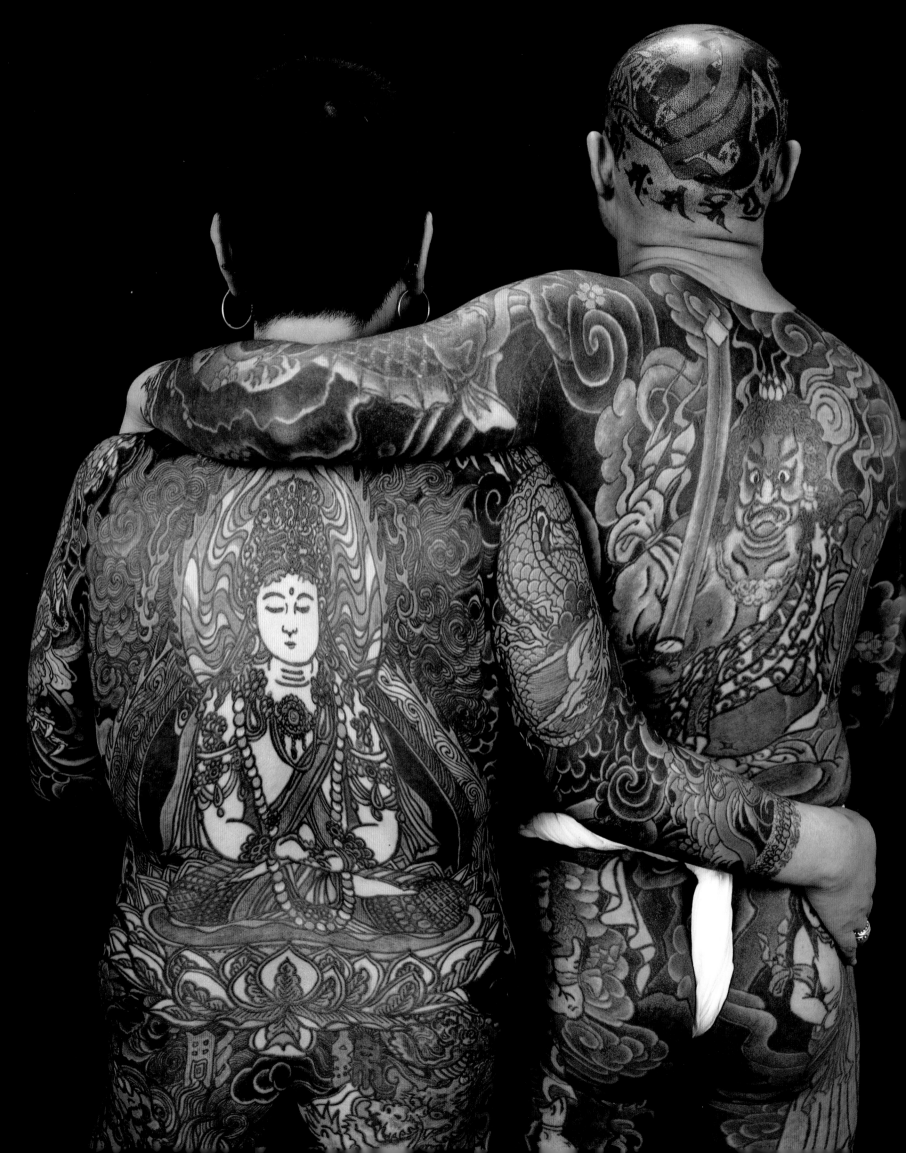

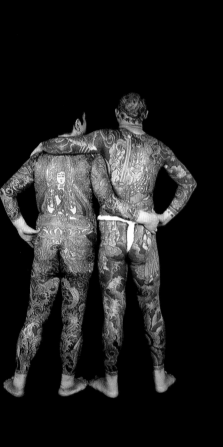

DEVOTION Appropriately, Horikin tattooed his wife's back with the Kwannon (Hindu *Avalokitesvara*), the Buddhist goddess who is the All-Merciful One Surveying the World with Pity, and who rides a Golden Carp. Kwannon sits on a lotus throne with her head surrounded in a halo of purifying flames. Over her left buttock Horikin has tattooed his "chop" or signature mark.

For his own back, Horikin chose Fudo (Sanskrit *Acala*), the Immobile One, meaning "Unmoved by Passion," one of the twelve Deva Kings or Buddhist divinities; this was tattooed by Horiyoshi III. Fudo the Destroyer is a central deity in esoteric Buddhism and the incarnation of the God of Wisdom, the Great Illuminator Dainichi, with the power "to foil the snares of devils." With his terrifying face he sits on a throne of flames, sword in his right hand to strike demons, and in his left hand, like a rosary, a lasso rope to bind them. Horikin has adopted Fudo as his patron saint.

Horikin's wife's hair is short because he is in the process of tattooing her head, which she shaves each time he begins work. Eventually they will both have identical patterns engraved on their scalps.

PRAYER The back of Horikin's wife shows the base of Kwannon's Lotus throne in Paradise surrounded by fierce guardian deities. Beneath it is Horikin's autograph in two red, lavishly stylized characters amid protective demons. Horikin was hesitant to have his wife's feet photographed because they were "unlovely and workworn."

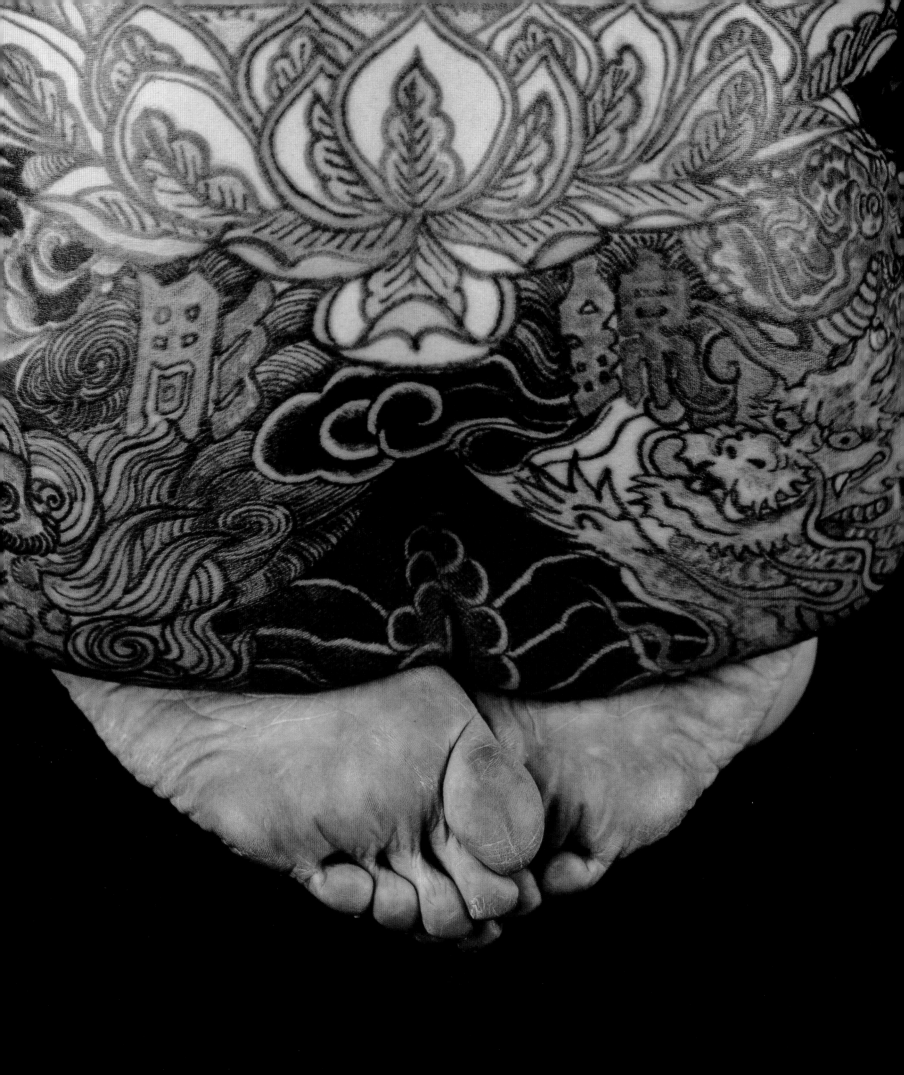

RED CLOTH Horijin's favorite areas of the body for tattooing are the hips and buttocks, and this is an example of some of his best work. In this unique design he has transformed the area into a Shinto modesty apron of straw rope and paper tassels, which Sumo wrestlers wear in the ring at matches. Combining with this bow to the wrestler's strength is a bravo character from the *Suikoden* holding a cloth dyed red with blood. Wrestler, fantasy hero, and tattooed man become one.

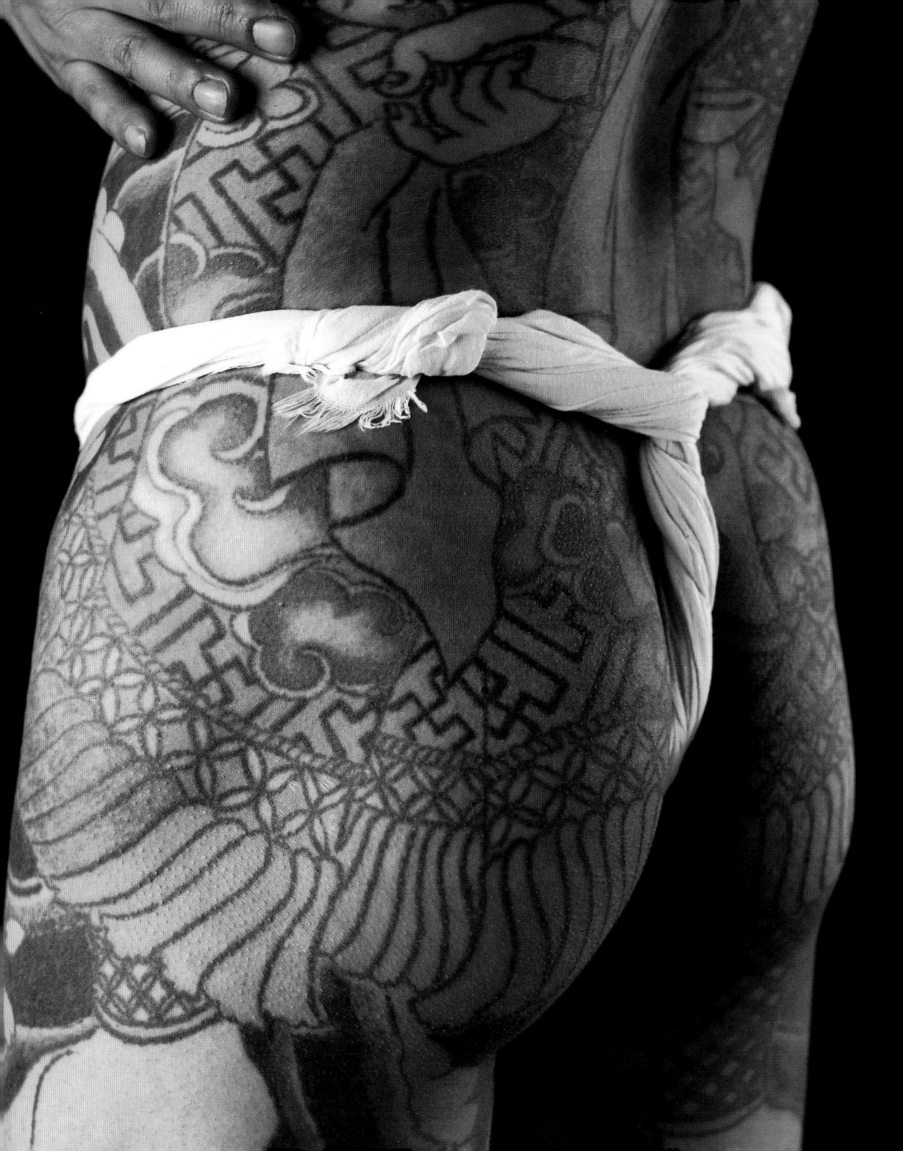

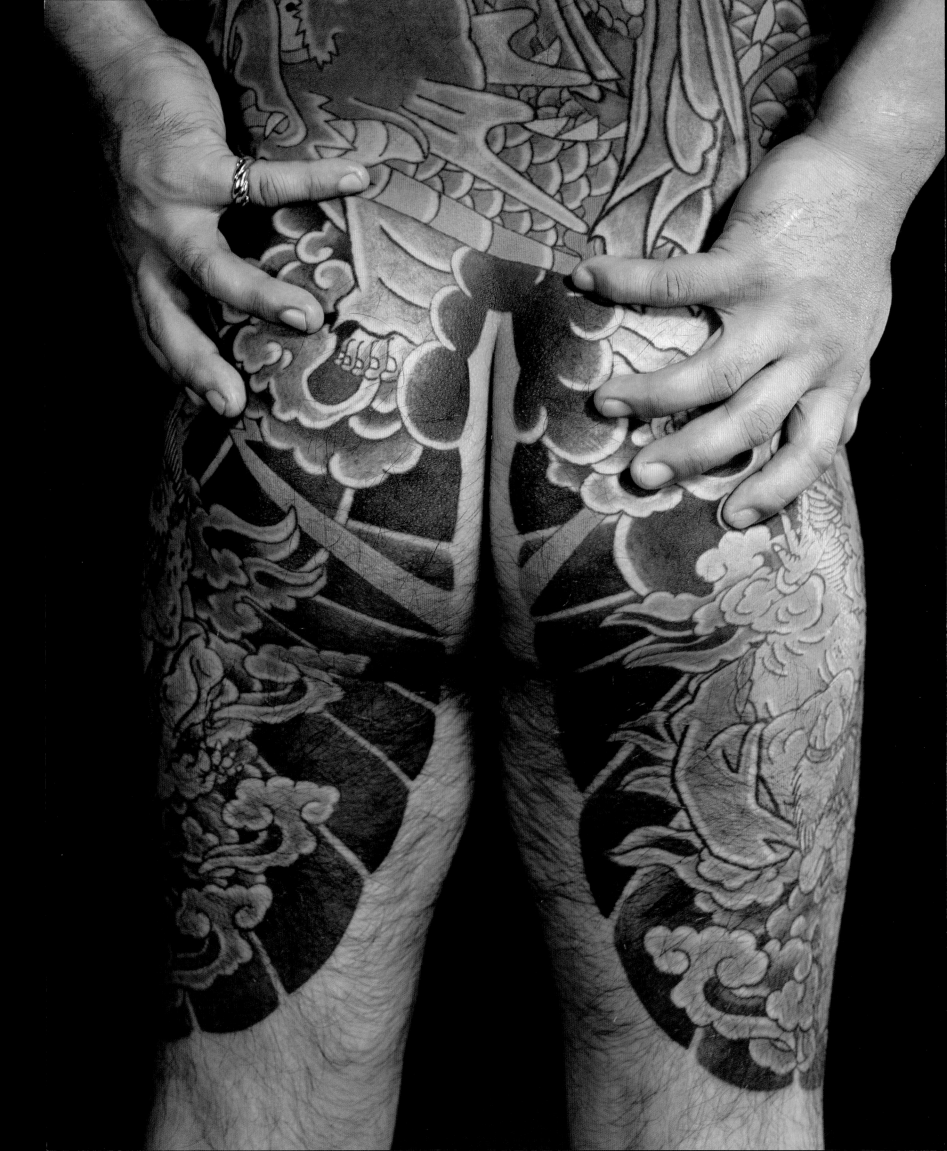

THUNDERBOLT Horiichi has tattooed a series of near abstractions on this client, who asked for "the fury of the elements." Here are wind, thunder, lightning, and clouds tossed in turbulence.

TABOO These men have been tattooed by Horikin on the left, and Horigoro II on the right. The prayer *Nam Myo Ho Ren Ge Kyo* (Hail to the Lotus Scripture of the Good Law) derives from the fanatical Nichiren sect of Buddhism founded in A.D. 1253, whose six million followers today are still much addicted to chanting and drumming. Their belief is that one perfect and sincere utterance of this single prayer will ensure rebirth in Nirvana, or Nothingness. The heavy leg tattooing on the man on the right was designed to cover severe scars. The Hail Lotus Sutra prayer is on the diagonal in red and upside down in gold to indicate either perversity or that Lord Buddha is omnidirectional. Both of these tattoos are particularly eccentric, in that they extend to the genitals. The penis is the last part of the anatomy to be tattooed and requires the most painful procedure of all. Two assistants hold the skin taut while the master tattoos in tiny sections. Many tattooees collapse after these sessions.

TRUST AND ORNAMENT (overleaf) Horikin, left, Horiuno, right; Horiuno, left, Horikin, right. The man on the far right has the Lotus prayer descending on his left leg and ascending upside down on his right leg. His body tattoo is the continuation of the famous battle between Heikuro and the Serpent seen earlier. The man on the left with the three-quarter body tattoo has a chivalrous commoner hero from Kabuki, with a stylish umbrella, tattooed on his back. One irezumi wears the additional ornament of a gold ring on his penis.

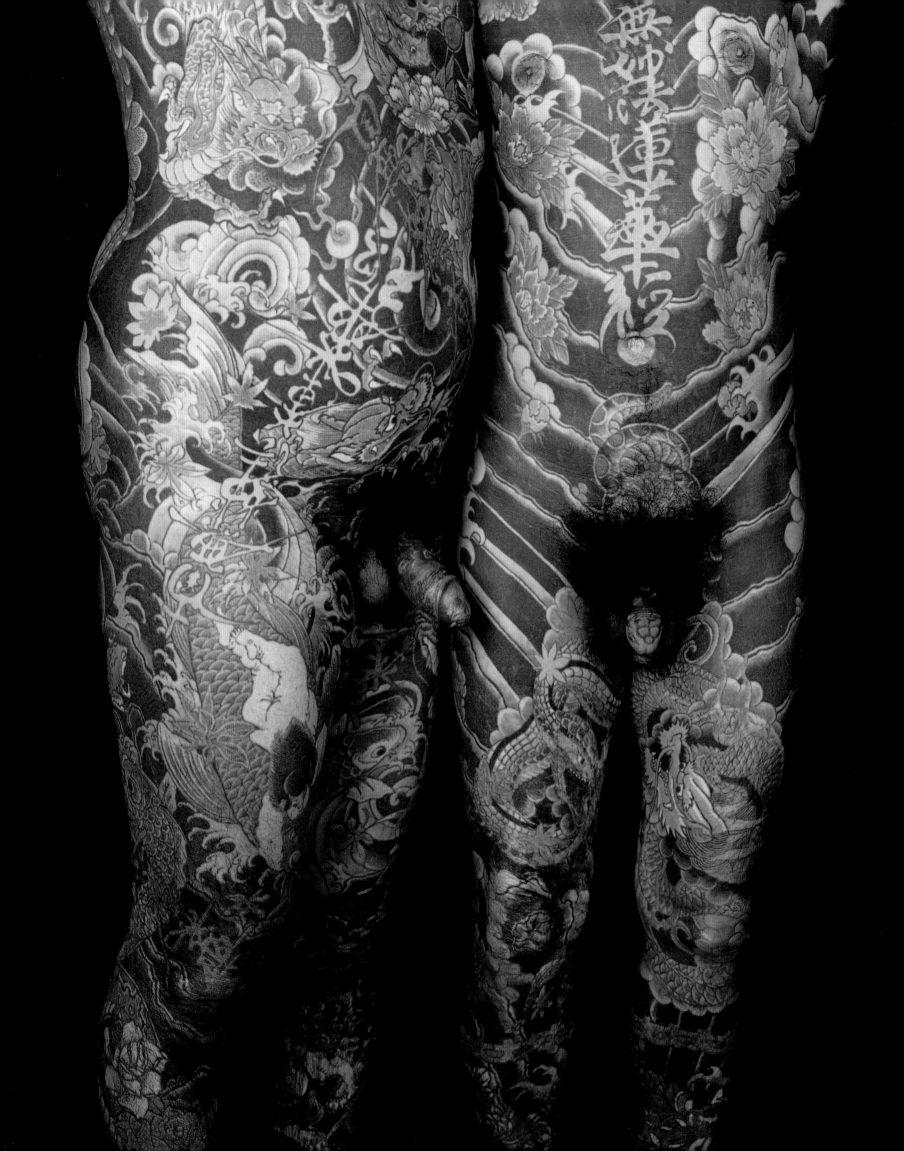

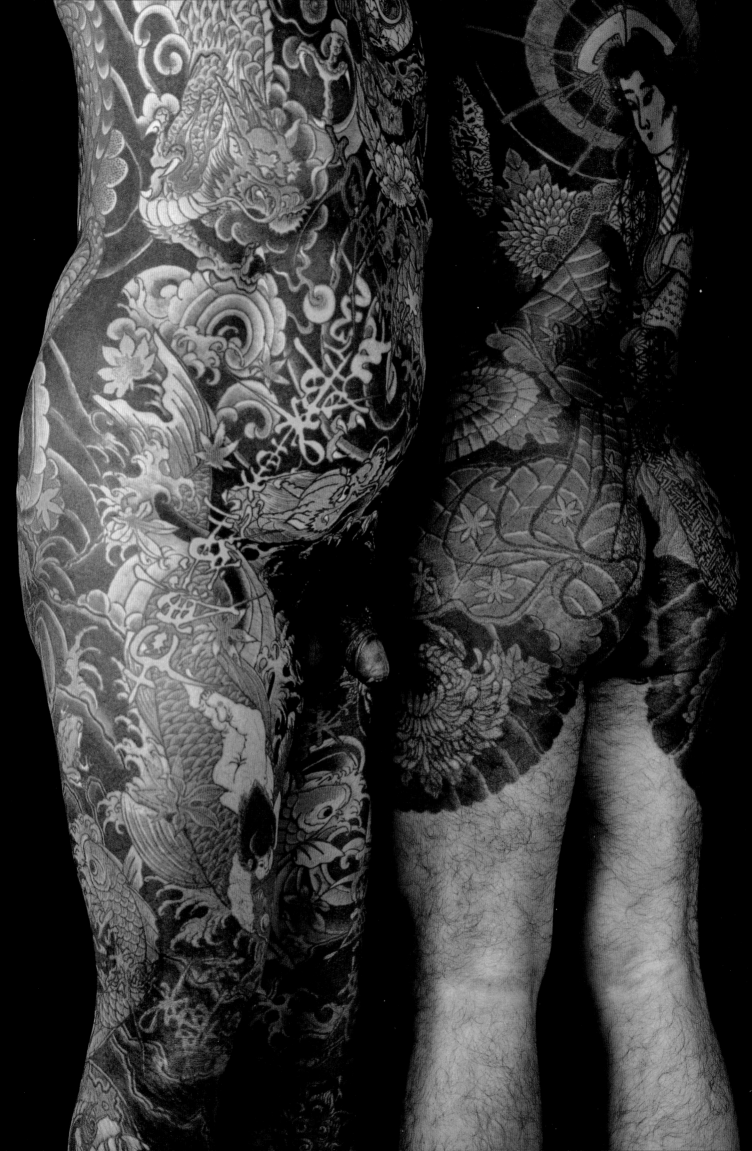

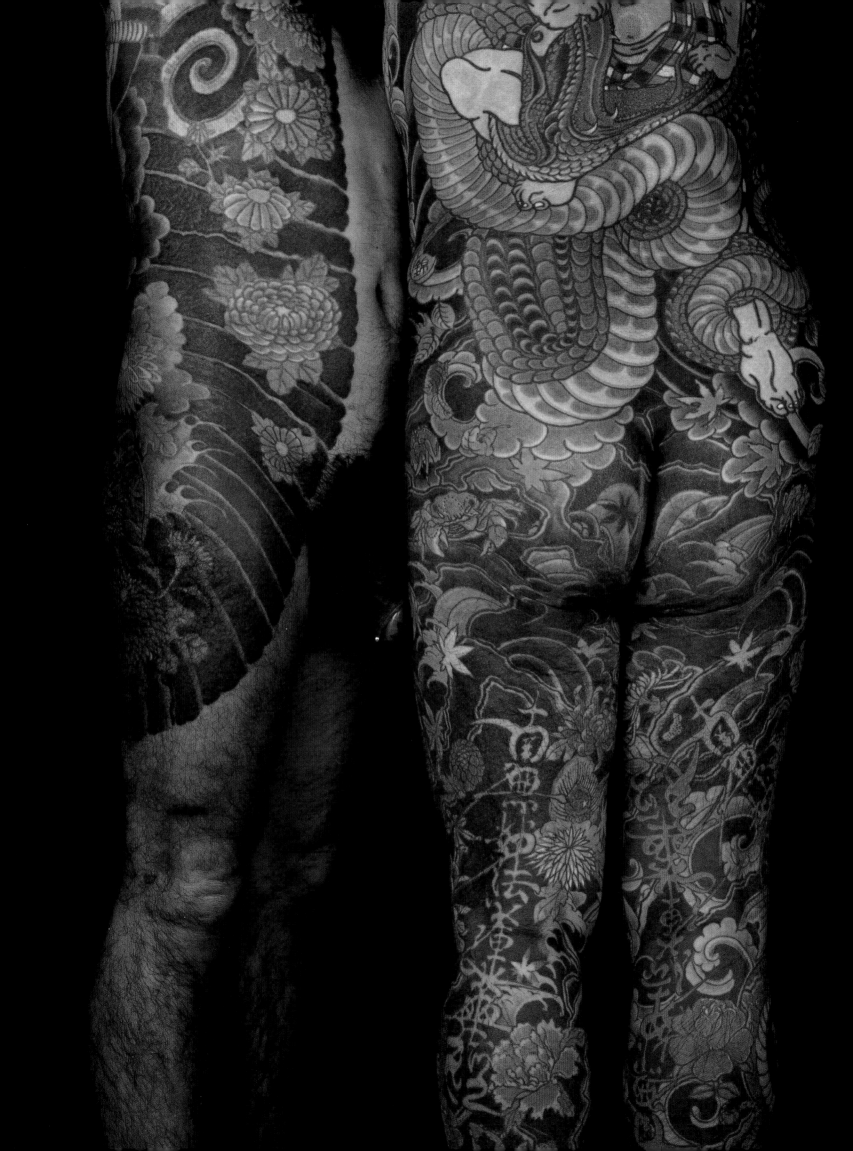

WATER Horikin delights in depicting earthly creatures and has varied traditional themes slightly. Young Kintaro here rides a slippery catfish, a red goldfish swims upstream to spawn, and the Lotus Prayer encircles the left thigh while a whiskered catfish forlornly cuts through the prayer.

Opposite: Close-up of Kintaro riding the catfish.

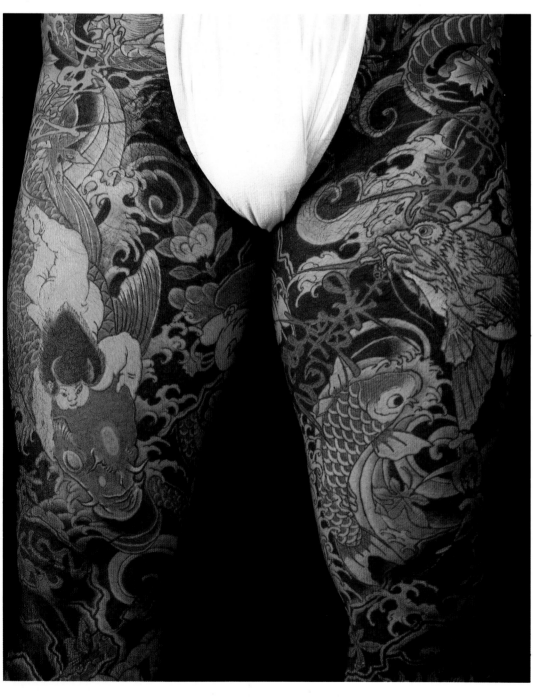

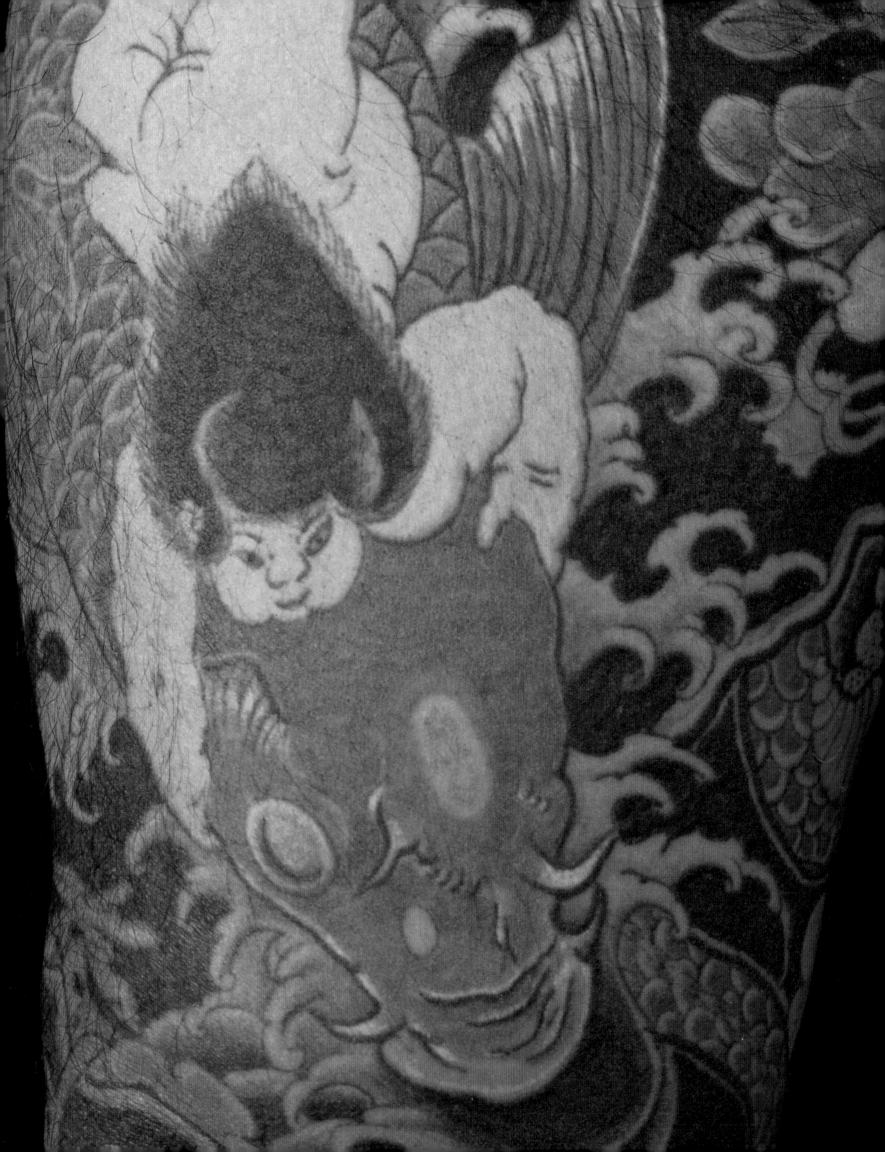

BLOSSOM Horiyoshi III turned for this full-back tattoo to Utamaro's *ukiyo-e* series of beautiful women of Yoshiwara's gay quarters, many of whom were themselves tattooed in the eighteenth century. The cherry blossom is one of the great symbols of Japan and popular in tattoo parlors. The blossom bursts upon the air in earliest spring, and within three days its petals fall. The brevity of its beauty links it inevitably to the warrior's short life and to the courtesan's brief span of youth and popularity. The courtesan depicted here has the flush of eroticism in the cherry color around her passionate eyes.

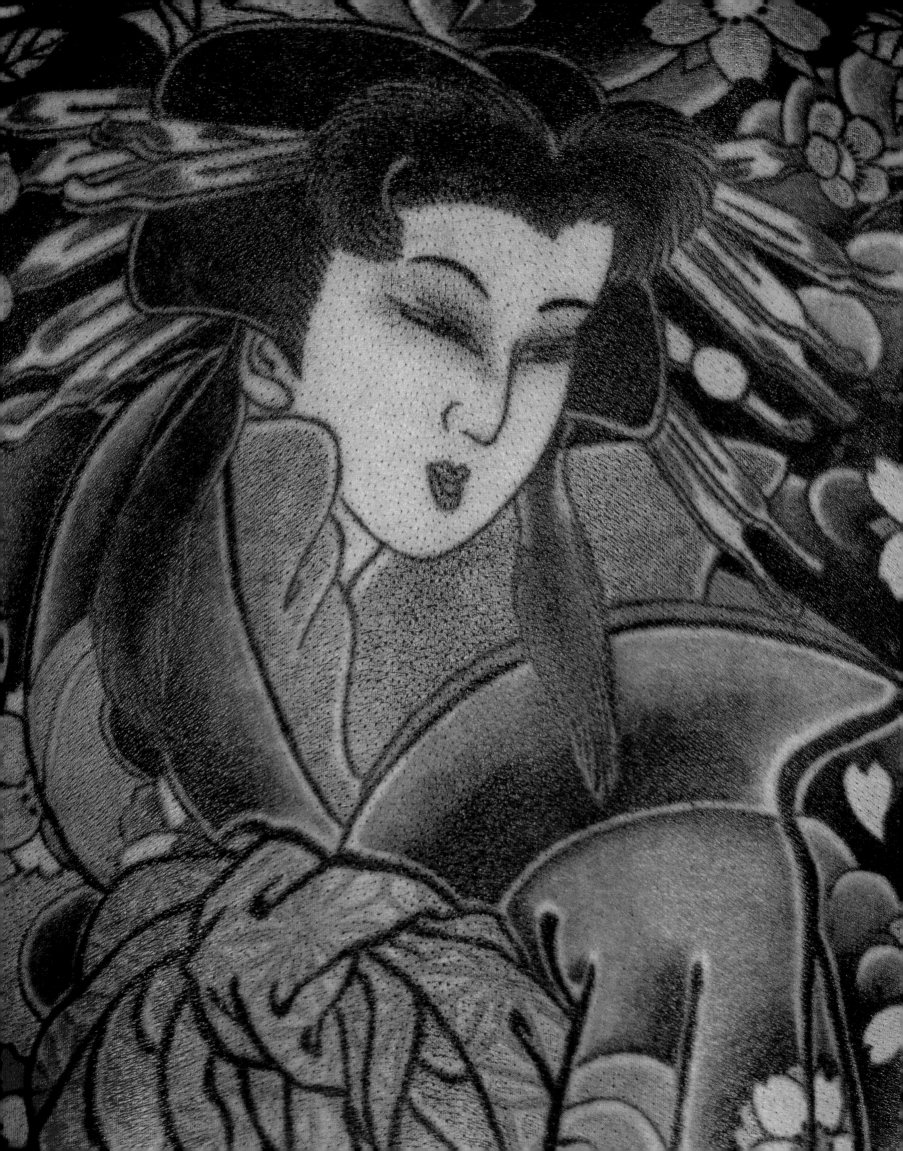

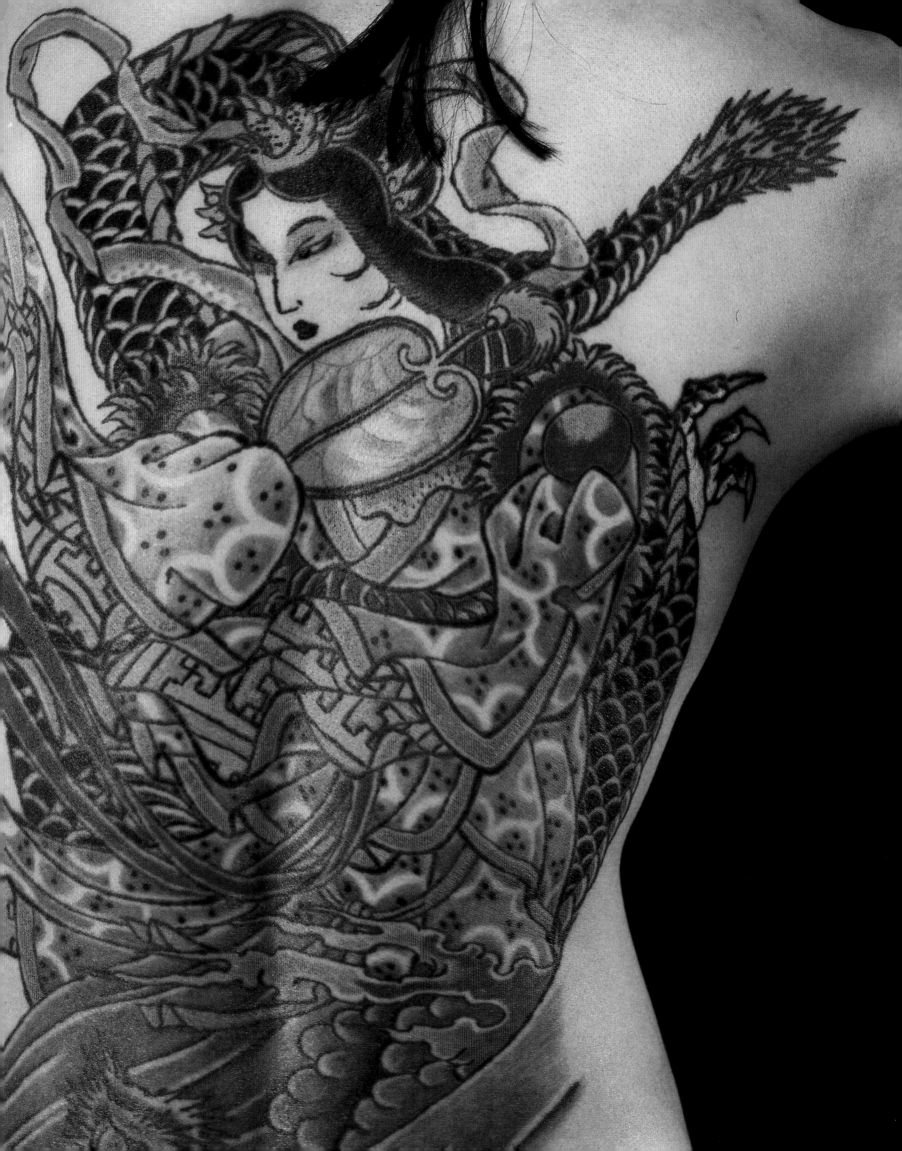

BENTEN WITH FAN Benten (Sanskrit *Sarasvati*) is the maiden deity of water and music and the only woman among the Seven Gods of Luck and Fortune. She represents the gentle arts of music, painting, literature, and soft speech. She is always pictured with a sea serpent and here is shown with her Chinese fan of yak leather. This masterpiece is signed Horiyoshi III (upper left-hand corner).

SIGNATURE Another version of Benten, deity of Good Fortune, the only female god still venerated in modern Japan. This time the tattoo is flamboyantly "chopped" by Horiyoshi III's official signature.

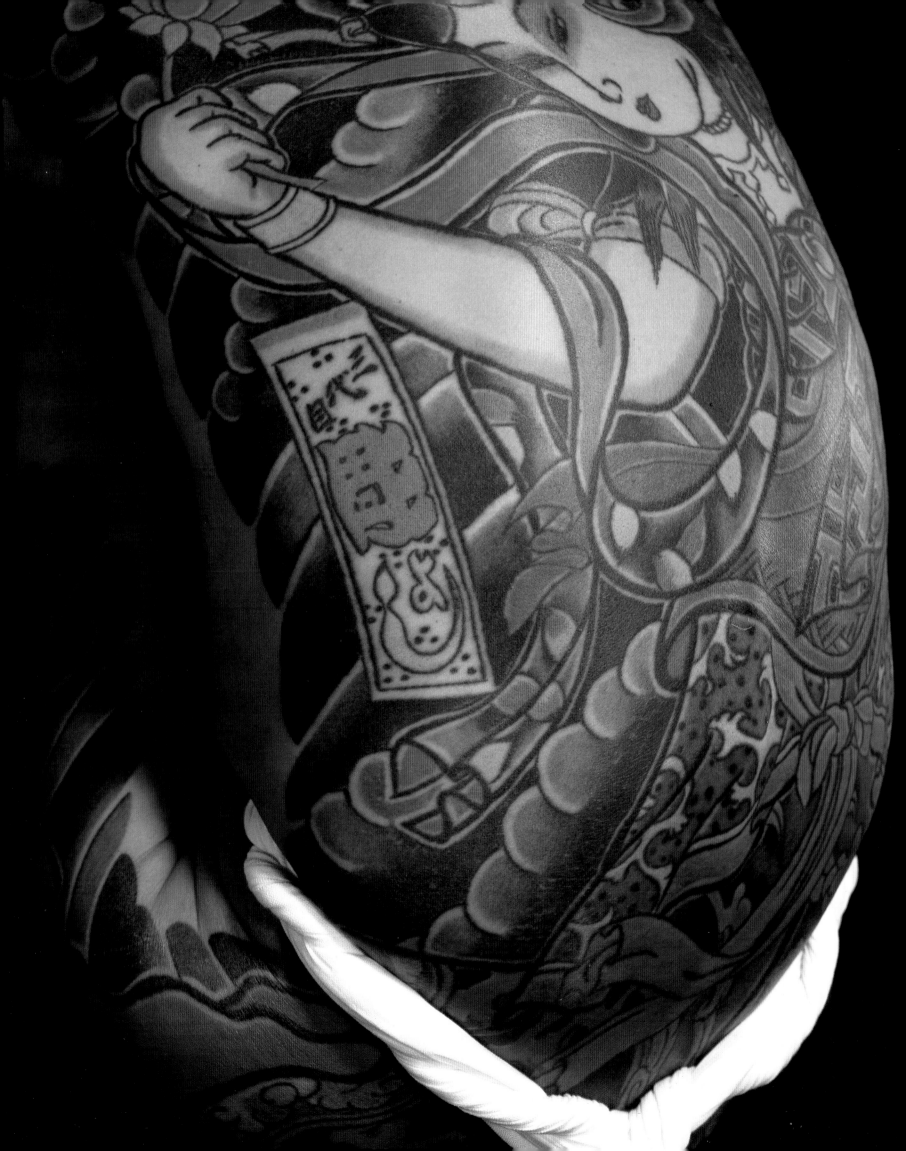

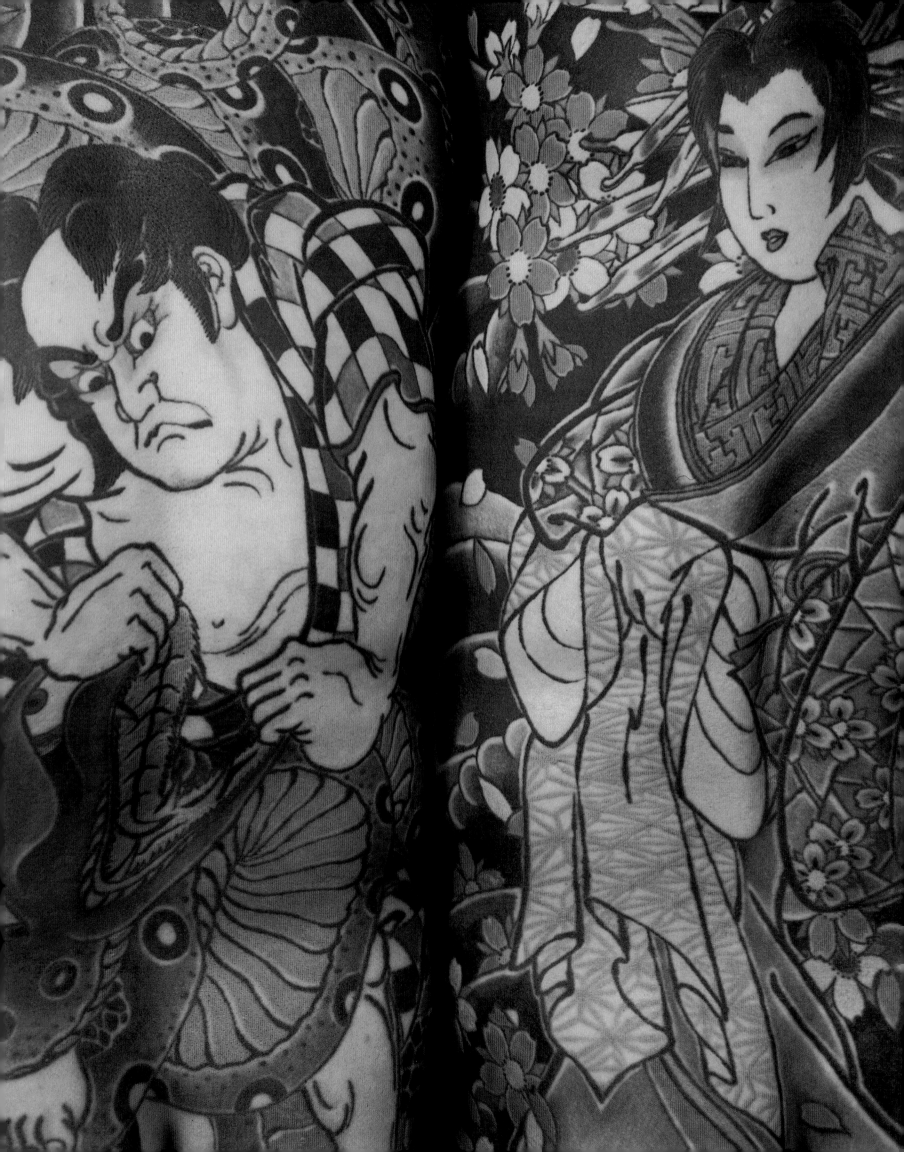

KABUKI PAIR New narratives were instantly formed as irezumi clustered together. Two separate tattoo scenes from Kabuki merge in this image. A seventeenth-century commoner hero forces open the mouth of a mythical crocodile beast (in reality a sorcerer) while his courtesan lover seemingly looks on in fright. (Note that the woman's obi is worn tied in front, jocularly said to be because she spent so much time on her back.)

VORTEX Horikin is perhaps the most skilled and knowledgeable tattoo master in Japan today, and this is one of his finest works. The design of this tattoo is intricate, and the colors uncommon, a combination of purples, white, and yellows, along with the more traditional black, green, red, and blue. His tattoo is extensive, covering all of his skin with the exception of his face and feet. Among the myriad images on his belly are a dragon, a Buddhist chant, and two reversed representations of a whirlwind.

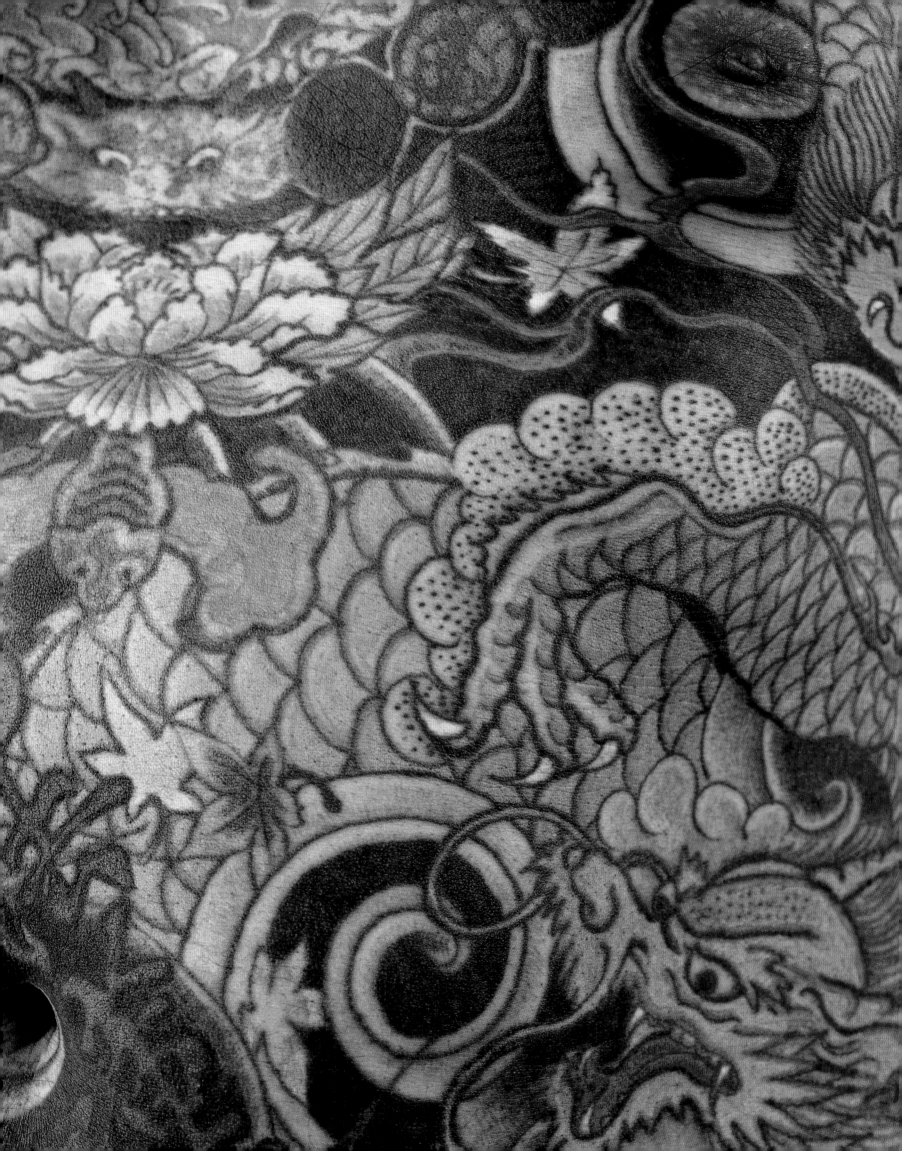

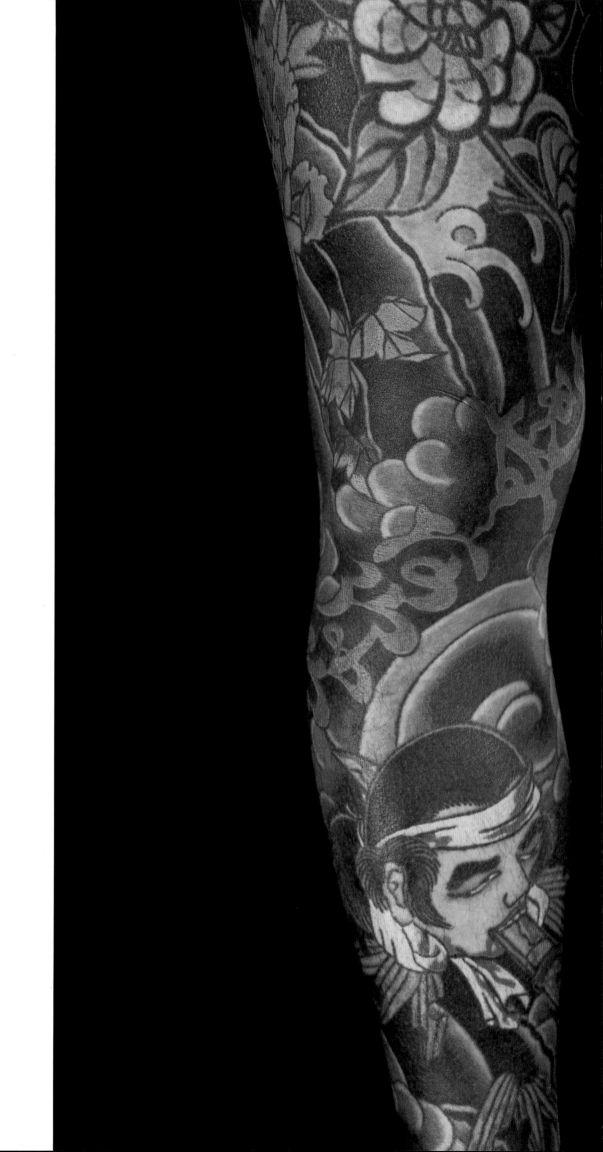

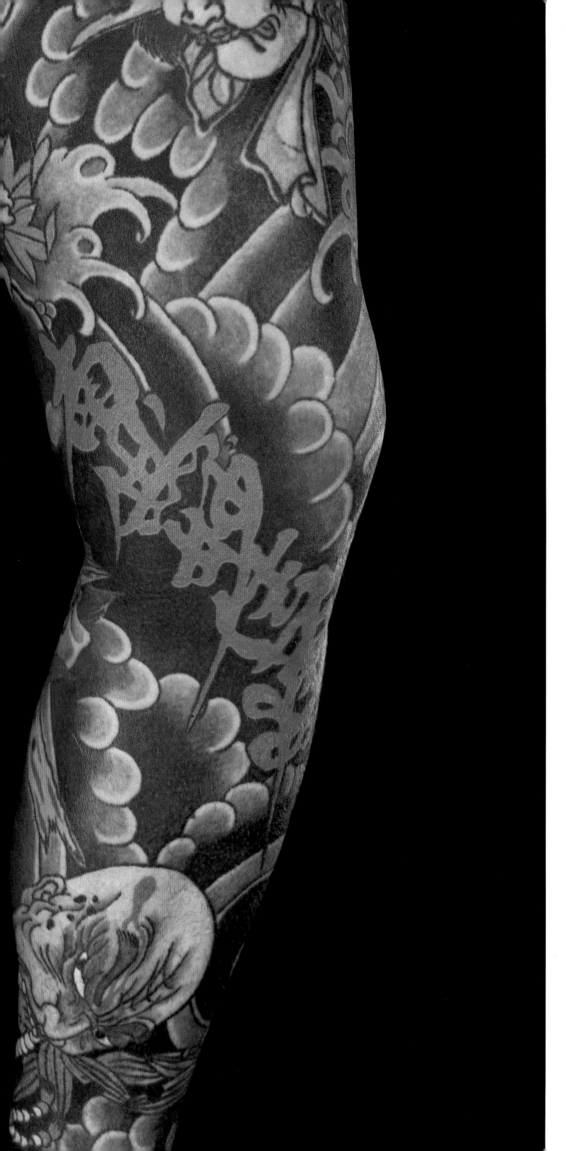

TROPHY The grotesque side of irezumi as tattooed by Horiyoshi III. The subject's calves show a decapitated head and a desiccated skull. Around the thighs Buddhist prayers curl diagonally. Both the artist and the tattooed person here are members of the Horiyoshi clan, whose tattoos are frequently sadomasochistic. Many members of the Horiyoshi *nakama* have their nipples pierced with rings and chains, as an extension of the ornamentation on their bodies. Pierced nipples are common to groups associated with Western tattoos— bikers, for example—but the rings are delicate, almost camouflaged, in keeping with the subtler Japanese approach.

EDEN More grotesqueries. Young Japanese are requesting this sort of gruesome and violent tattoo, done here by Horiyoshi III. Again the cherry blossom, Japan's national flower, to emphasize the shortness and transience of life—and the snake of temptation. Perhaps this is a Christian-influenced version of the Garden of Eden story seen through Japanese eyes.

SEPPUKU (below) A dying man shown just after he has committed *harakiri* (literally, stomach cutting), more properly *seppuku*.

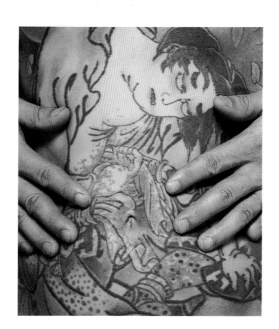

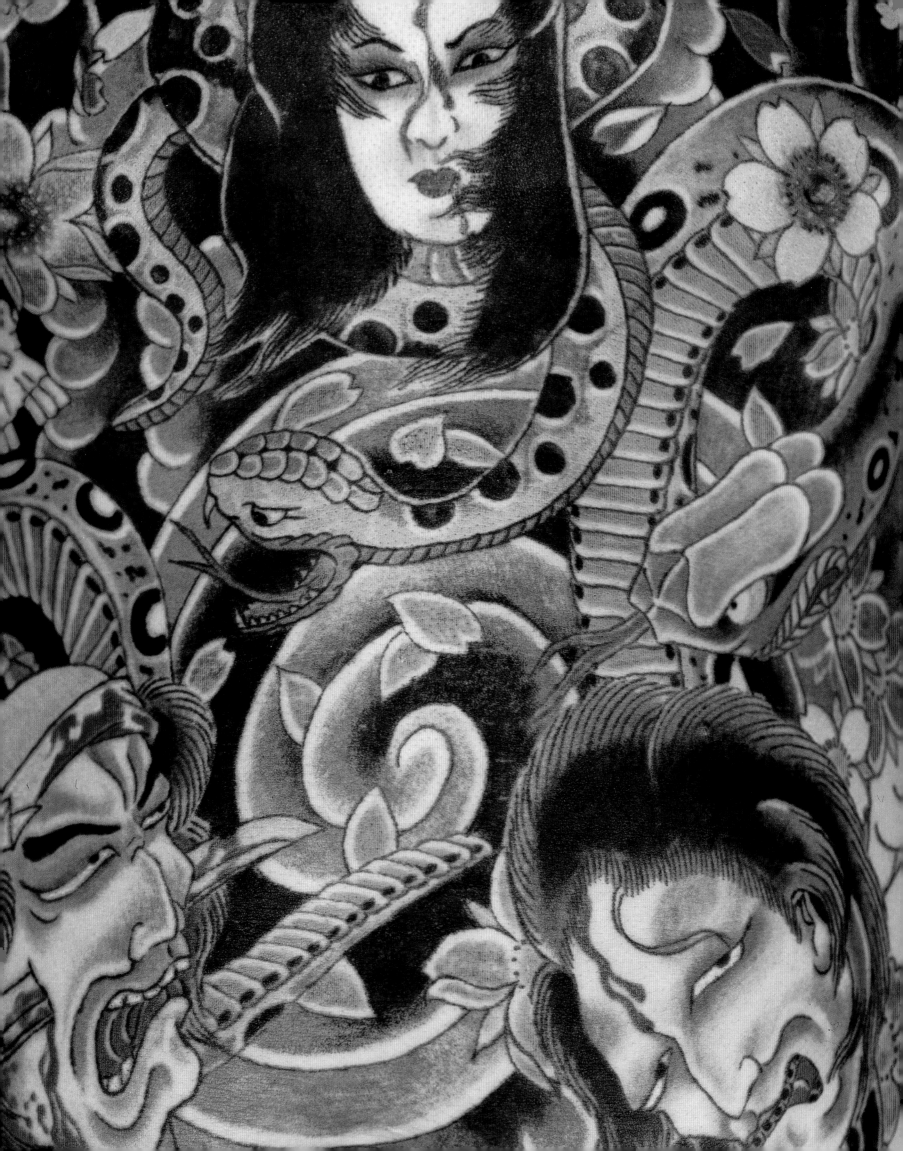

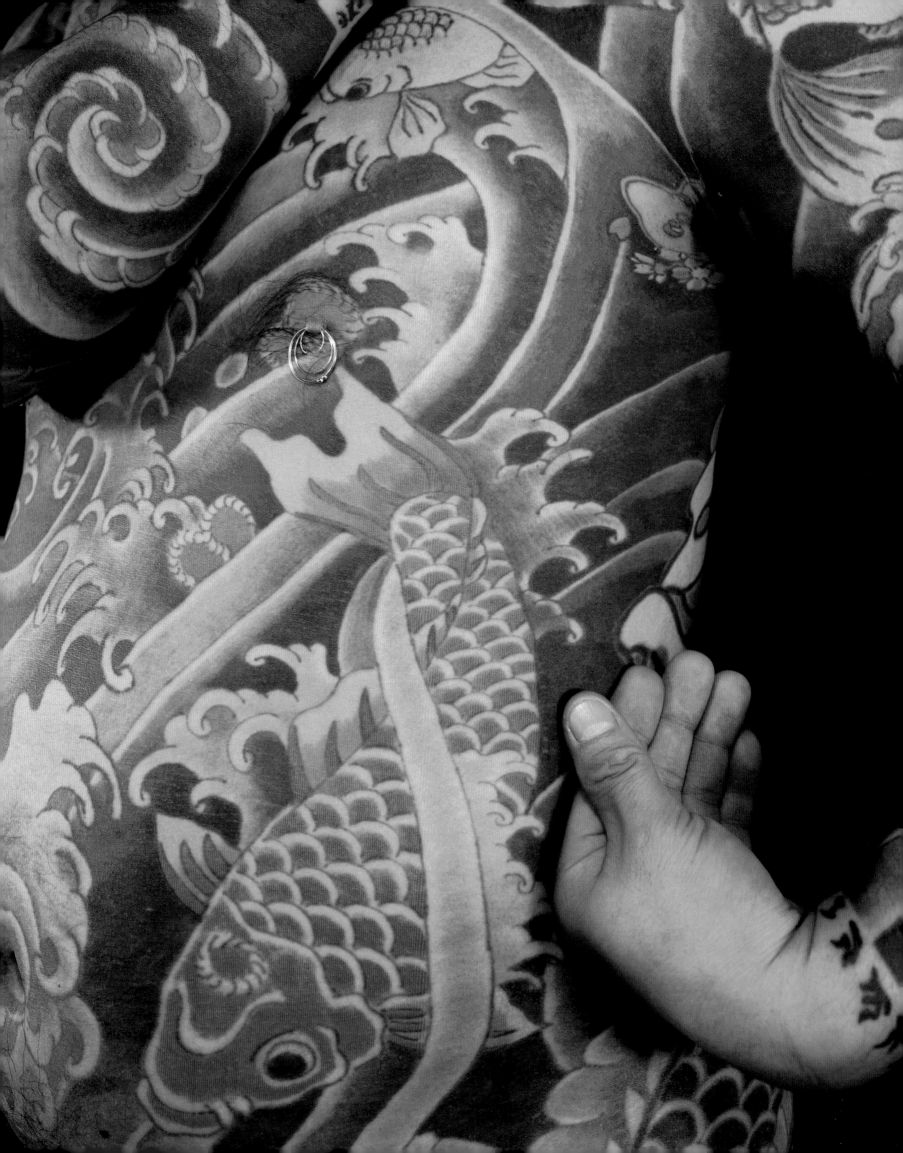

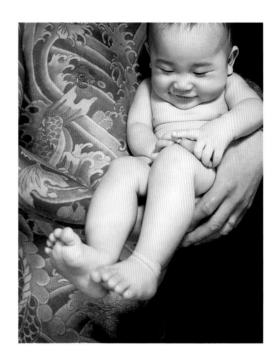

CARP The subject here is Horiyoshi III himself, as tattooed by his master Horiyoshi II. The scene is a fantasy of ocean waves and wind, eddies and whirlpools, all celebrating the persistence and fortitude of the heroic carp. Note the pierced nipple.

Above: Horiyoshi III holding his as yet untattooed son.

NINJA RAT This subject was born in the Year of the Rat, the first one in the Oriental Zodiac. He chose the Ninja Rat for his back tattoo by Horikin. No one can explain why the rat, a rodent and a pest, should be honored in Japan's mythology. Nevertheless, the rat is associated with the God of Wealth, one of the Seven Deities of Luck, and is depicted in iconography ferreting around the rich man's bales of rice. The rat is also connected with fecundity, as can be seen from this humorous tattoo, here and overleaf, with its chorus of rat children sniveling around the parent Super Rat. The rat also symbolizes the ancient Japanese art of subterfuge, or *ninjutsu*, where the ninja, secret agents or spies, could make themselves as

invisible as rats in order to enter a castle stronghold to steal, murder, or merely reconnoiter. Ninja were stealthy, appeared in the darkness of night (for invisibility), and mystically they were assumed to be able to take other shapes, notably the rat itself (as in the Kabuki play *Nikki Danjo*) or the "raccoon dog" famous for its ability to scale trees in an instant.

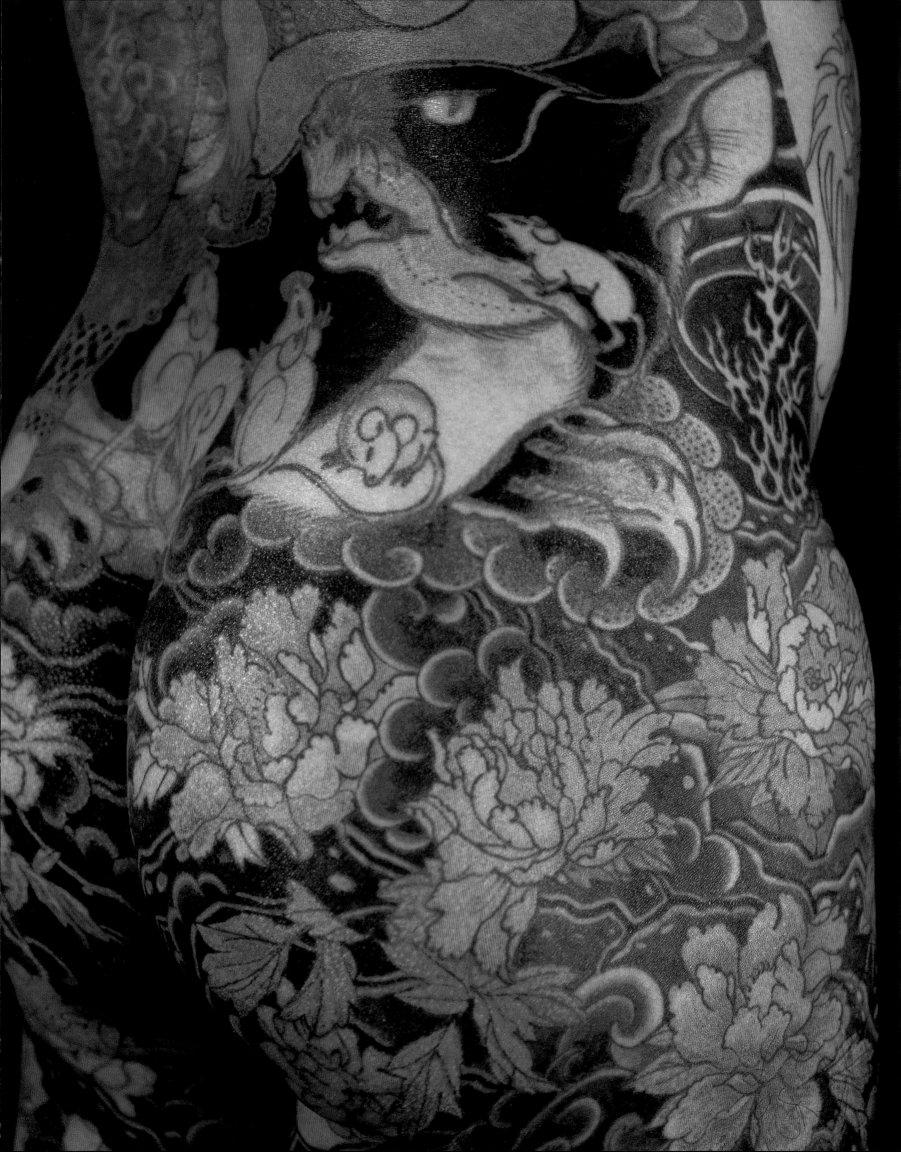

KABUKI PLAYBOY Benten Kozo, one of the most popular and beloved scoundrels of the Kabuki repertoire was a thief whose beauty was such that he could disguise himself as a woman and ply his trade to great effect. When he is caught stealing from a dry goods store, he at last reveals himself as a man and undresses from women's clothing to expose a very tattooed man. It is this stage moment that Horijin has captured in this tattoo. The client's spine divides the tattoo: the left side shows Benten still in women's clothing; the right side reveals his masculine tattoos. The whirlwind pattern is not only decoration but also suggests the chaotic, destructive course of Benten Kozo's life-style.

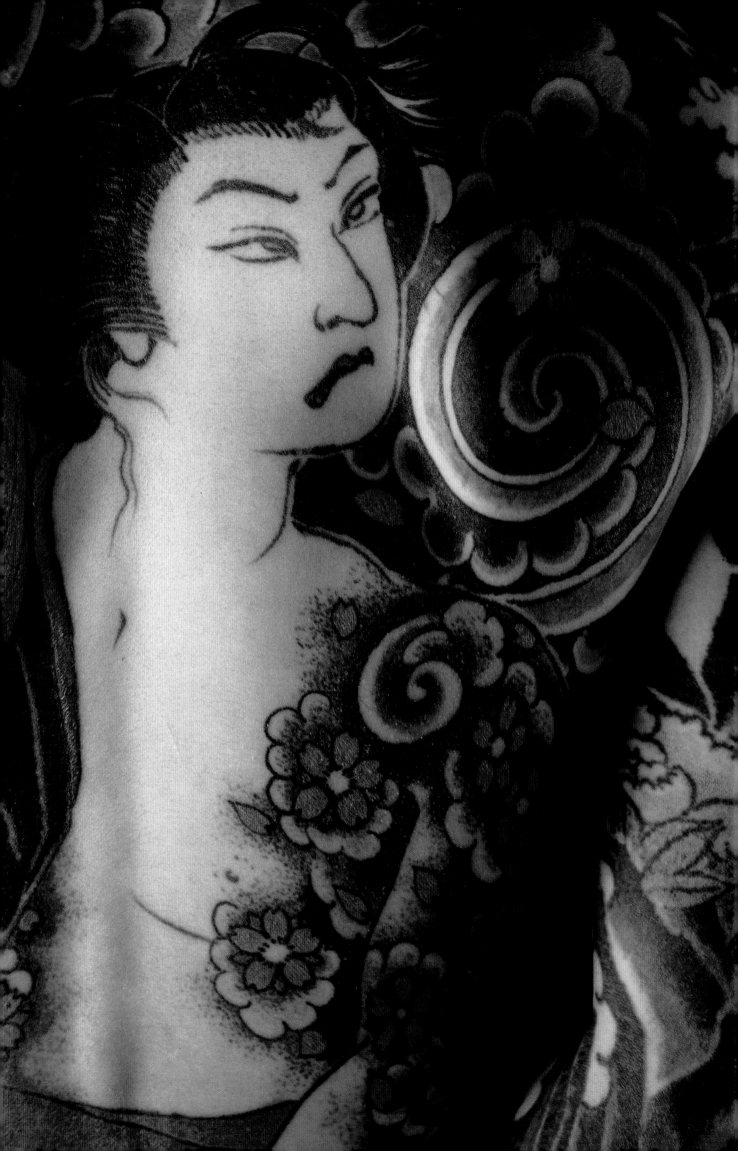

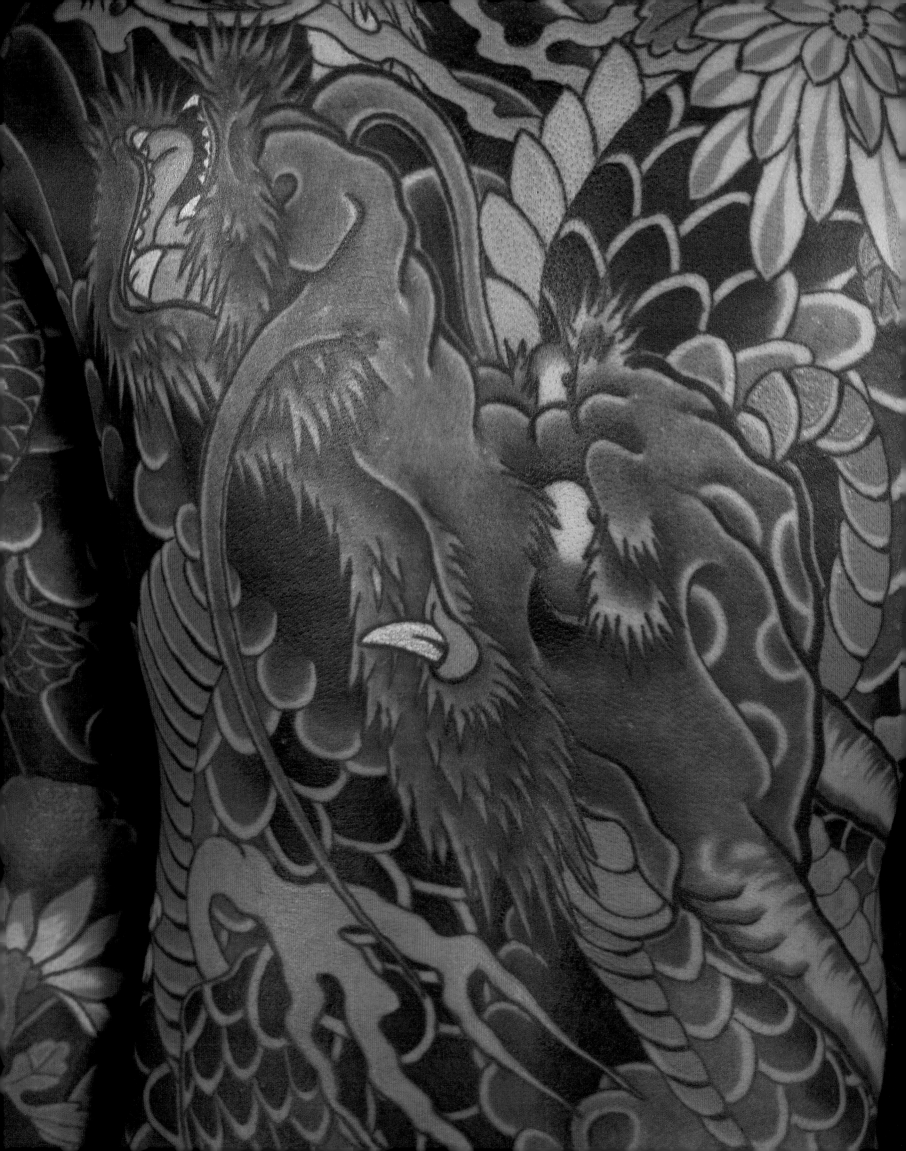

GRAY DRAGON A detail of the dragon motif showing Western influence. In the cartoon style of *manga* (comic book) influence, Horiyoshi III has catered his genius to youthful tastes and given the traditional dragon a furry skin, a snout in the upper left-hand corner, fangs at the back of the jaw in the center, flamelike appendages and downward-pointing horns. The dragon and its background compose the yin-yang elements of opposites resolved and wholeness or oneness reinforced.

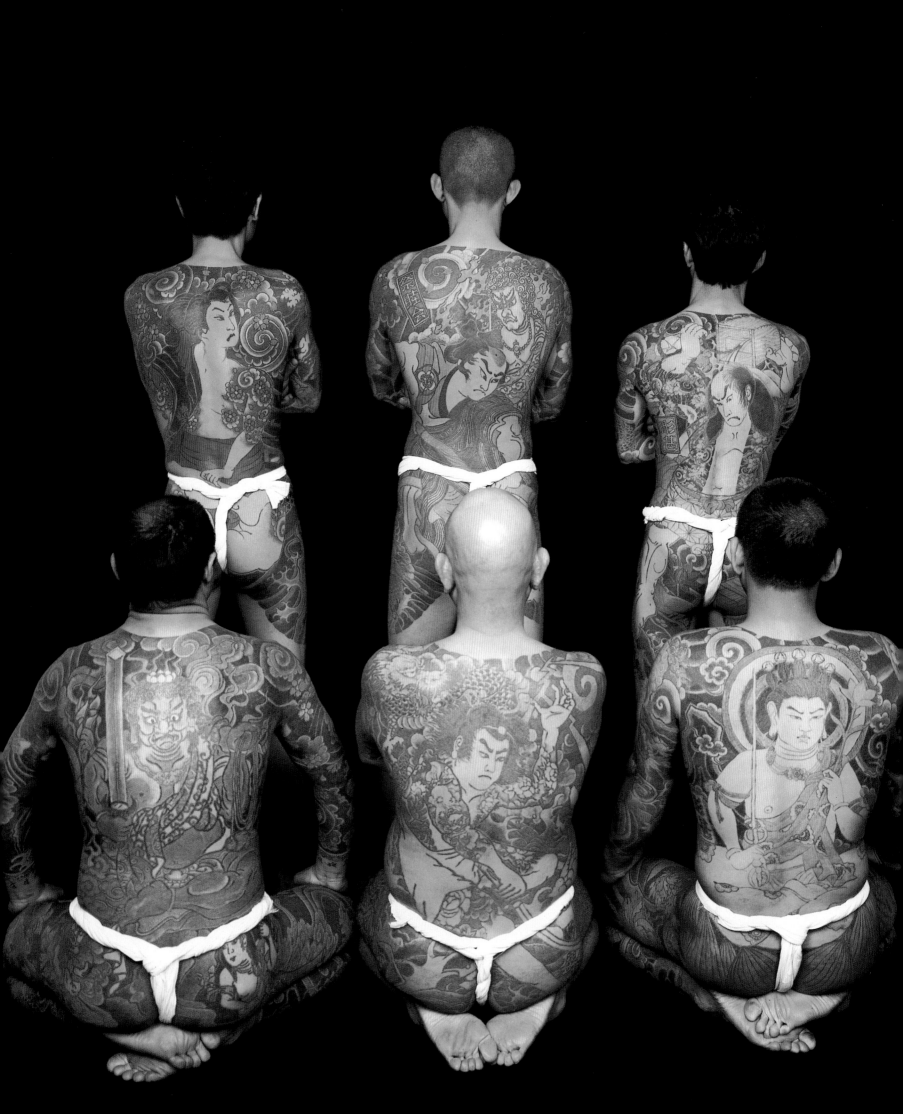

The two group portraits show some
of my favorite and most loyal models,
and include the front and back of
Mitsuaki Ohwada—Horikin. Here
the men assumed more formal and
traditional irezumi poses for the
camera.

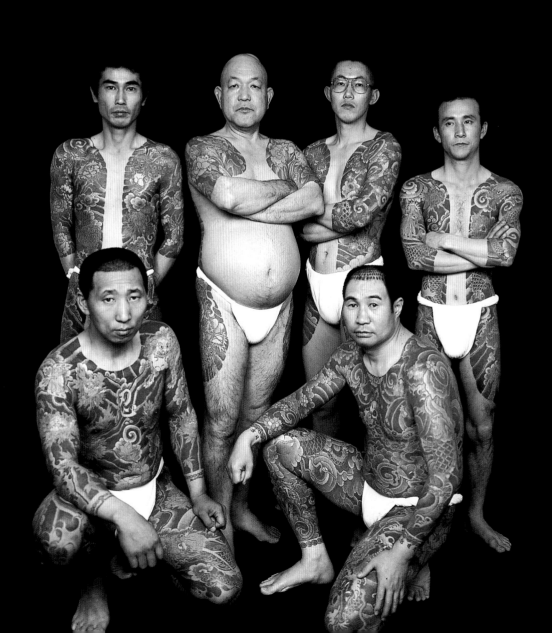

KINTARO AND MAPLE LEAVES

Kintaro again in mortal struggle with the powerful carp. This time he is older, armed, fully clothed, and tied with a bow at the obi (in lieu of the *haramaki*). The maple leaves suggest the passage of time or aging. Horiichi's signature chop, or *han*, is at the top left of the full-back tattoo.

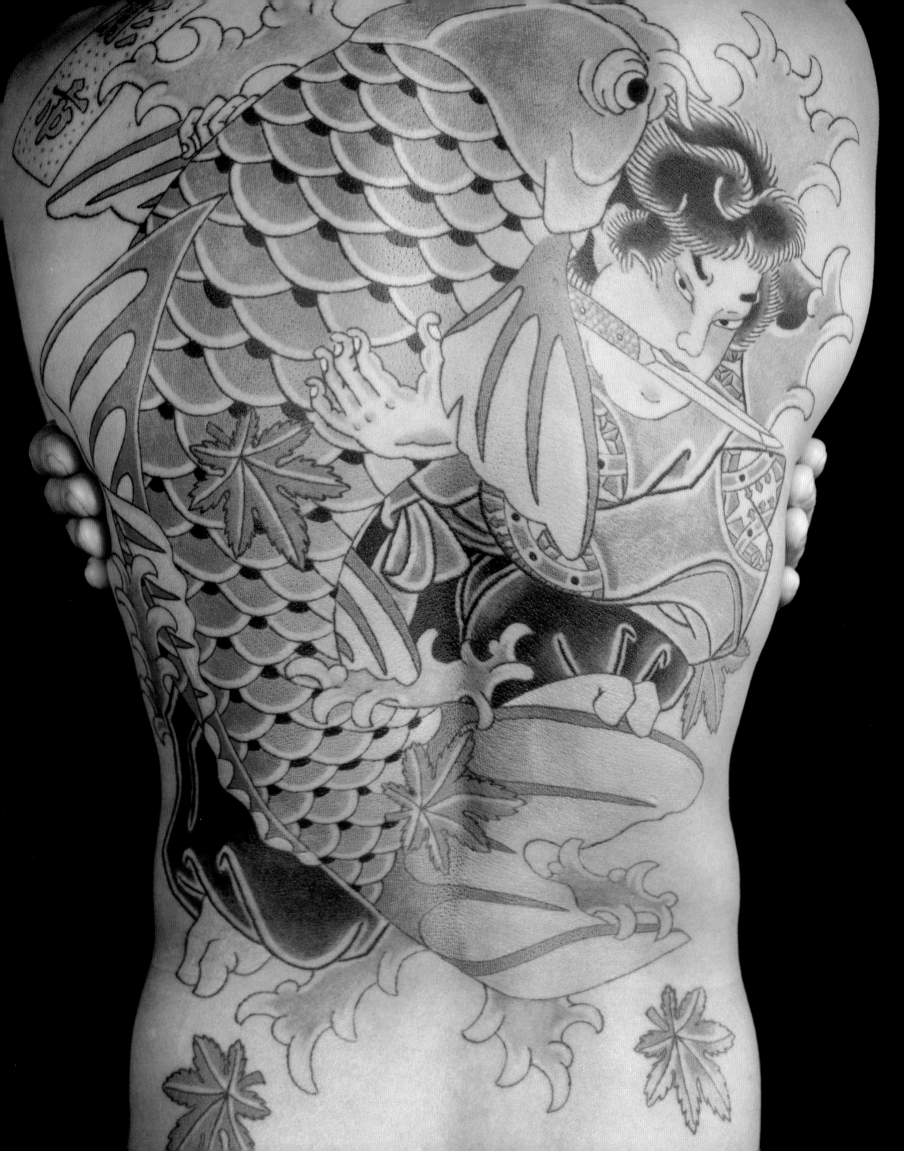

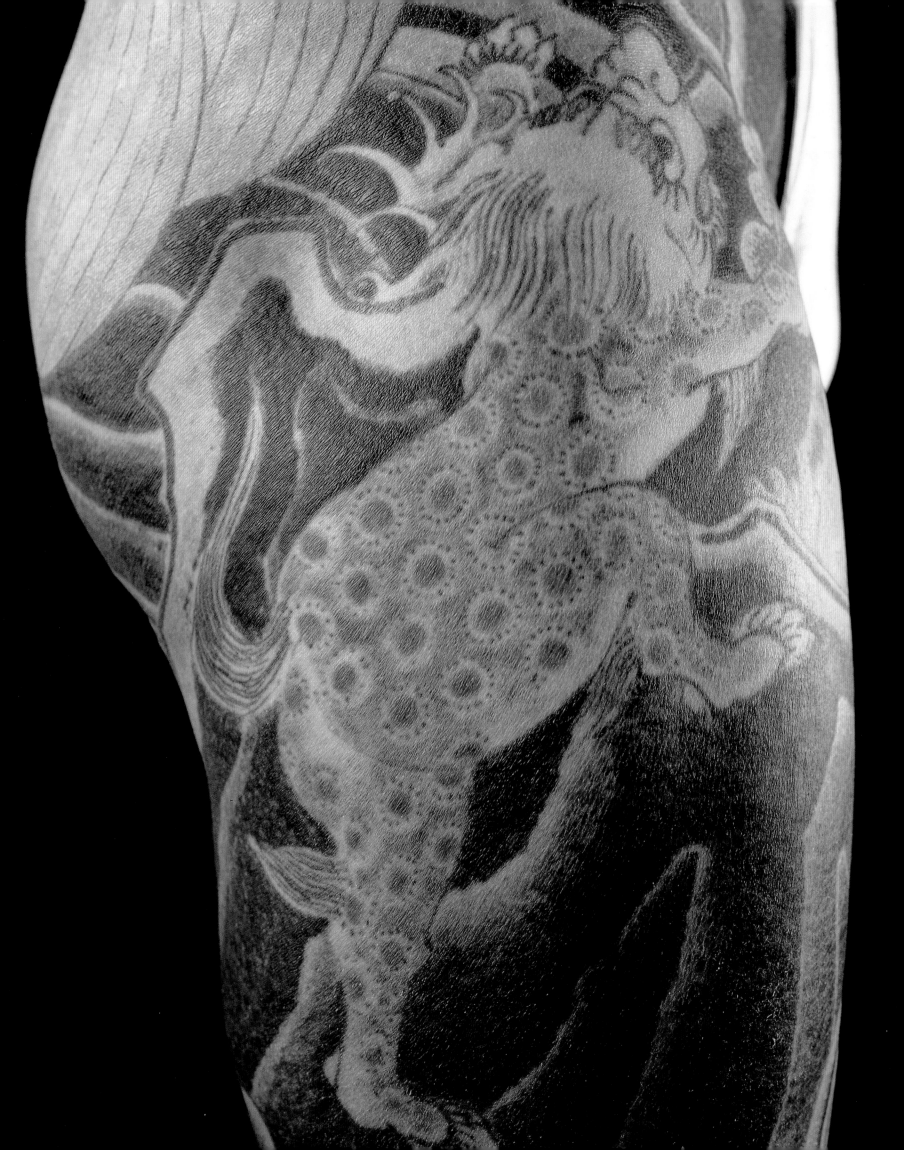

PERSEVERANCE Horijin tells here the famous Chinese story of the lioness mother who tossed her favorite, still suckling cub down a ravine to train and encourage him to climb back to her. It is a legend of the survival of the fittest and symbolic of the Confucian ideal of parents sacrificing feeling so that their offspring may strengthen.

PEONY AND SWORD AND SERPENT'S TAIL (overleaf) Horiyoshi III combines opposites in the contrasting tattoos of the sword and the peony, indicative of strength and beauty in control of the horned demons of this world, and the serpent and the rope, so similar yet so unalike.

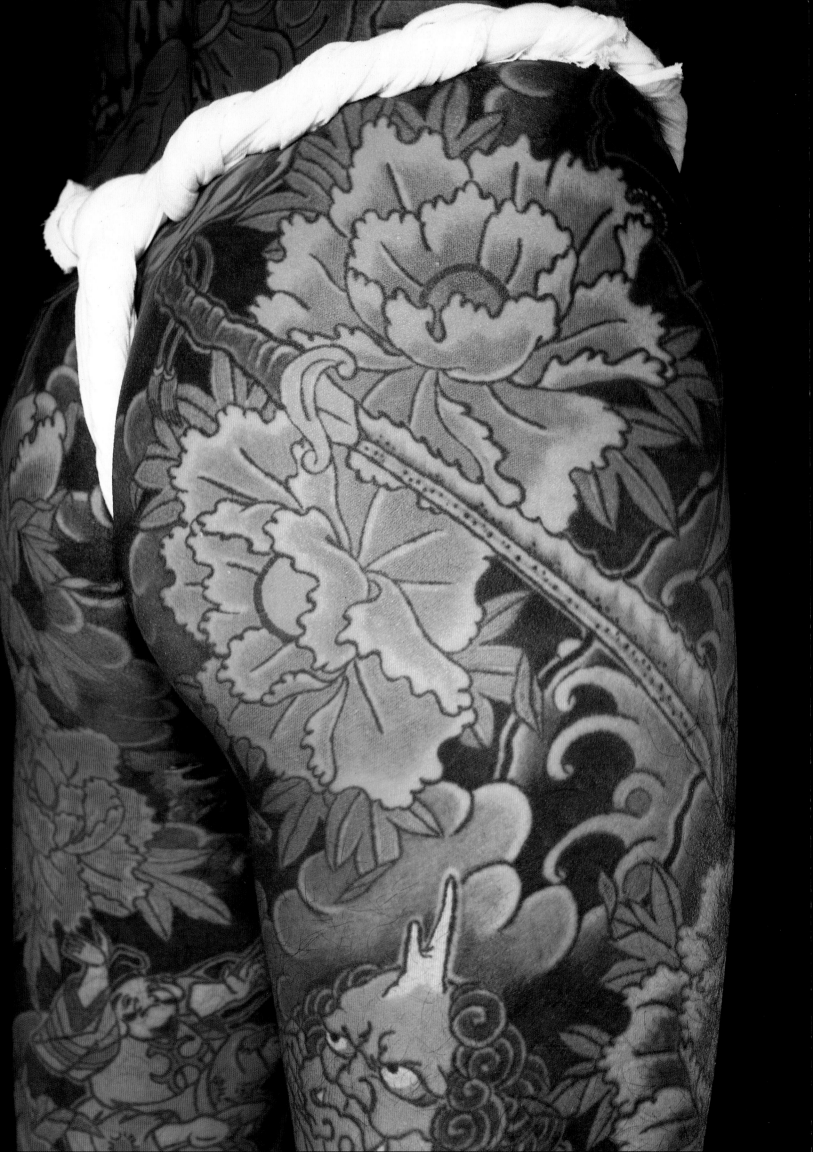

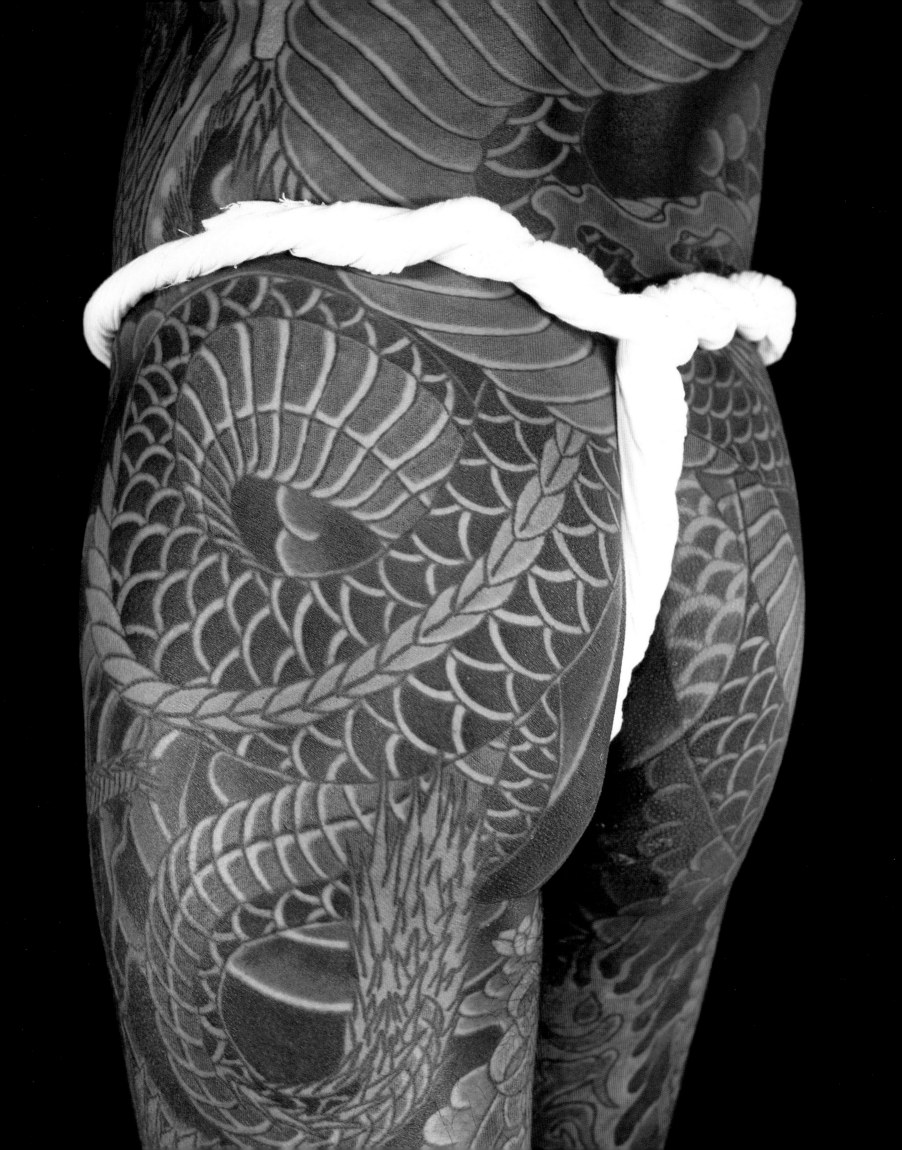

STRENGTH In this tattoo by Horijin, Kurikara Kengoro, one of the heroic outlaws from the *Suikoden* tales, has set out to oppose evil and correct wickedness. This time he is protected by the Buddhist deity Fudo. The rectangular cartouche (upper left) names the band to which the Men of the Marshes belong.

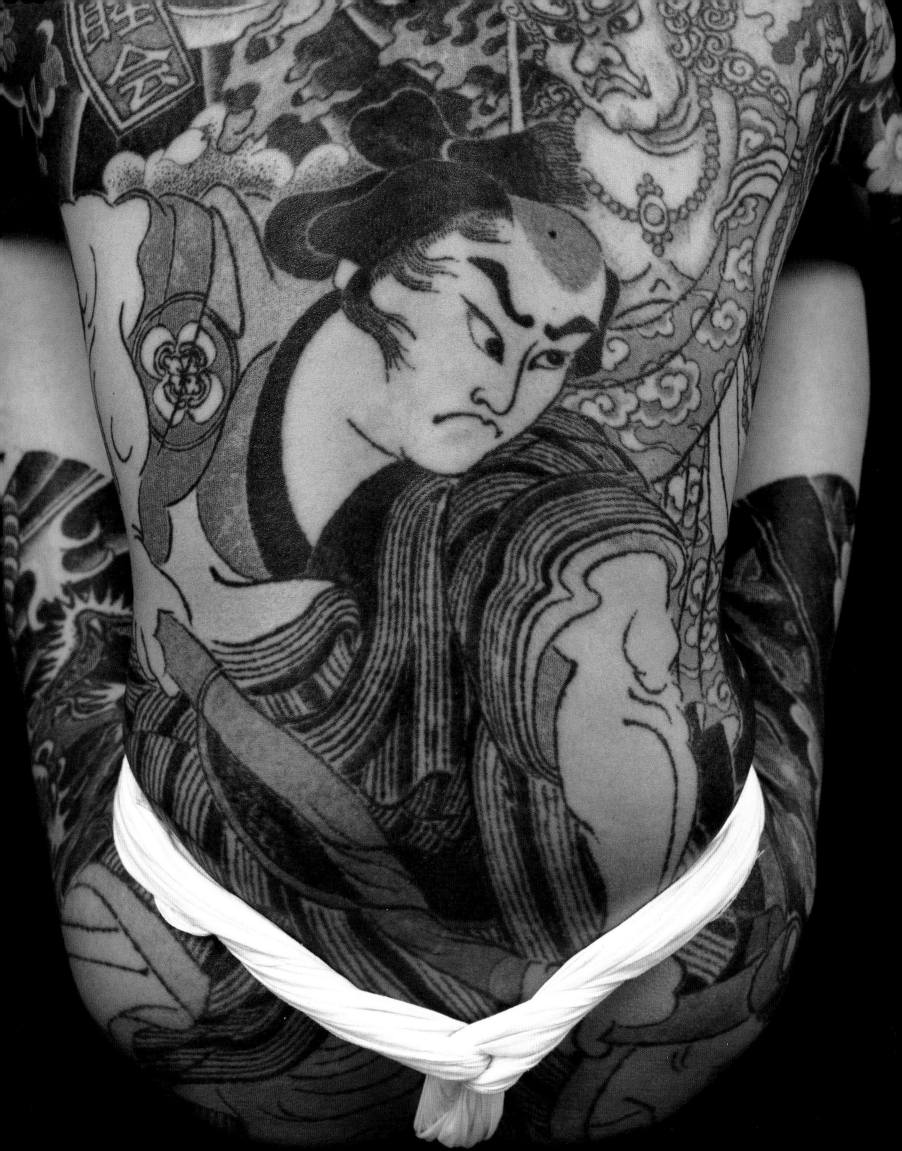

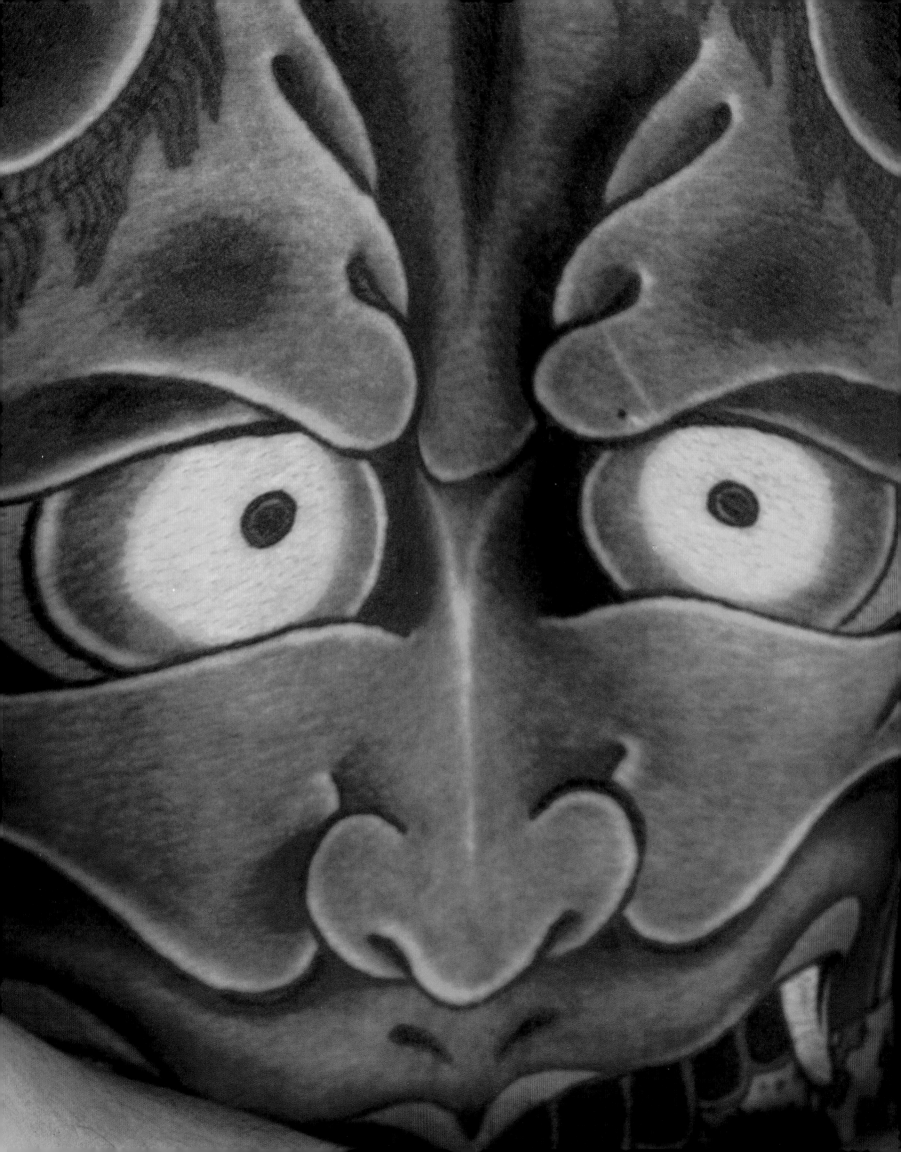

JEALOUSY An original, Western-influenced rendition by Horiyoshi III of the Japanese traditional concept of the two-horned devil (*oni*) of jealousy. According to Japanese folklore, jealous women grow similar horns. In the wedding ceremony, they are hidden by the bride's white headdress. Many young Japanese today prefer images of generic toughness like these to traditional patterns.

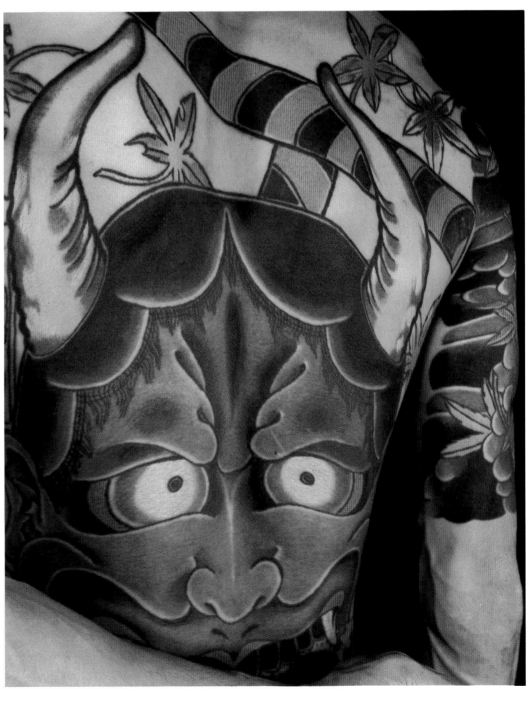

PHOENIX Horiyoshi III selected for his wife's back the legendary phoenix, the eternal bird of mythology who rises reborn out of the ashes of destruction again and again. The couple first met at a festival where Horiyoshi was displaying his tattoos, and his wife admits to having had an instant attraction.

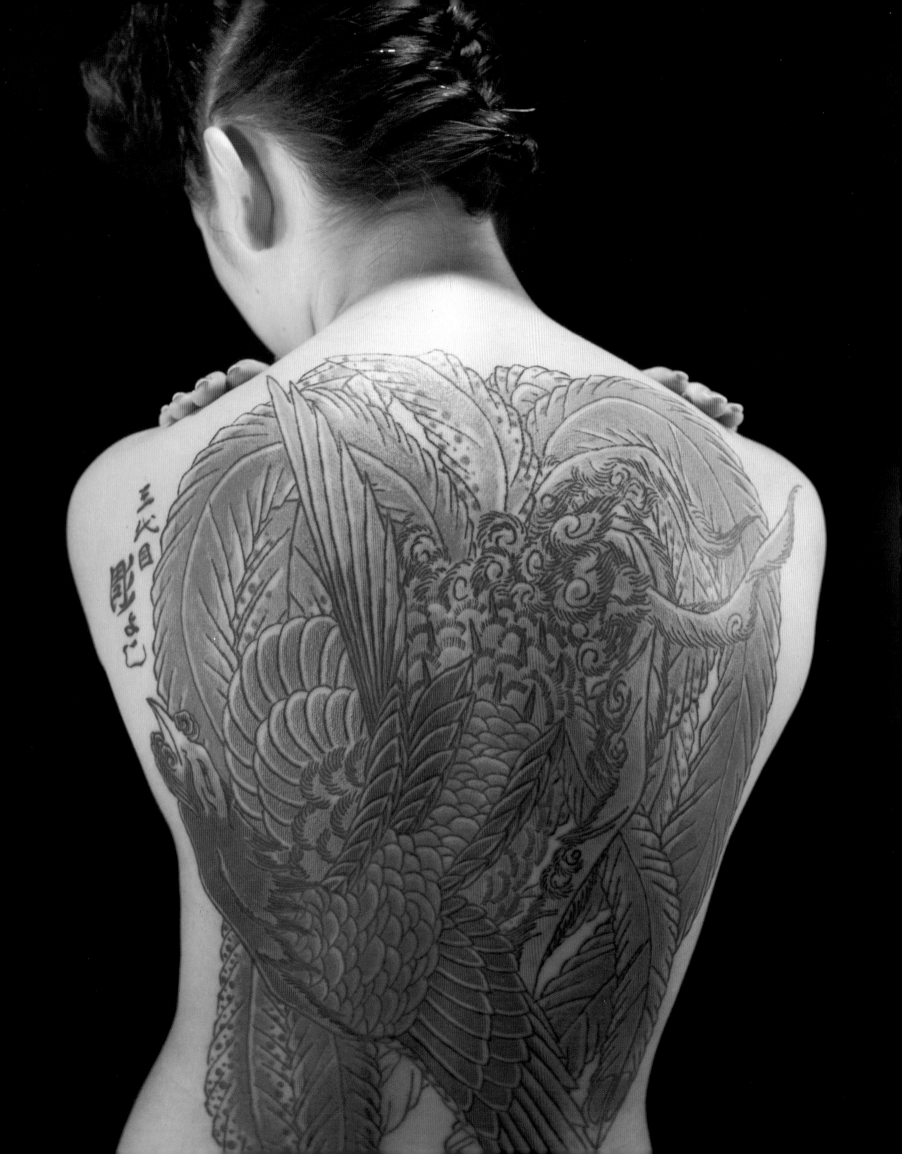

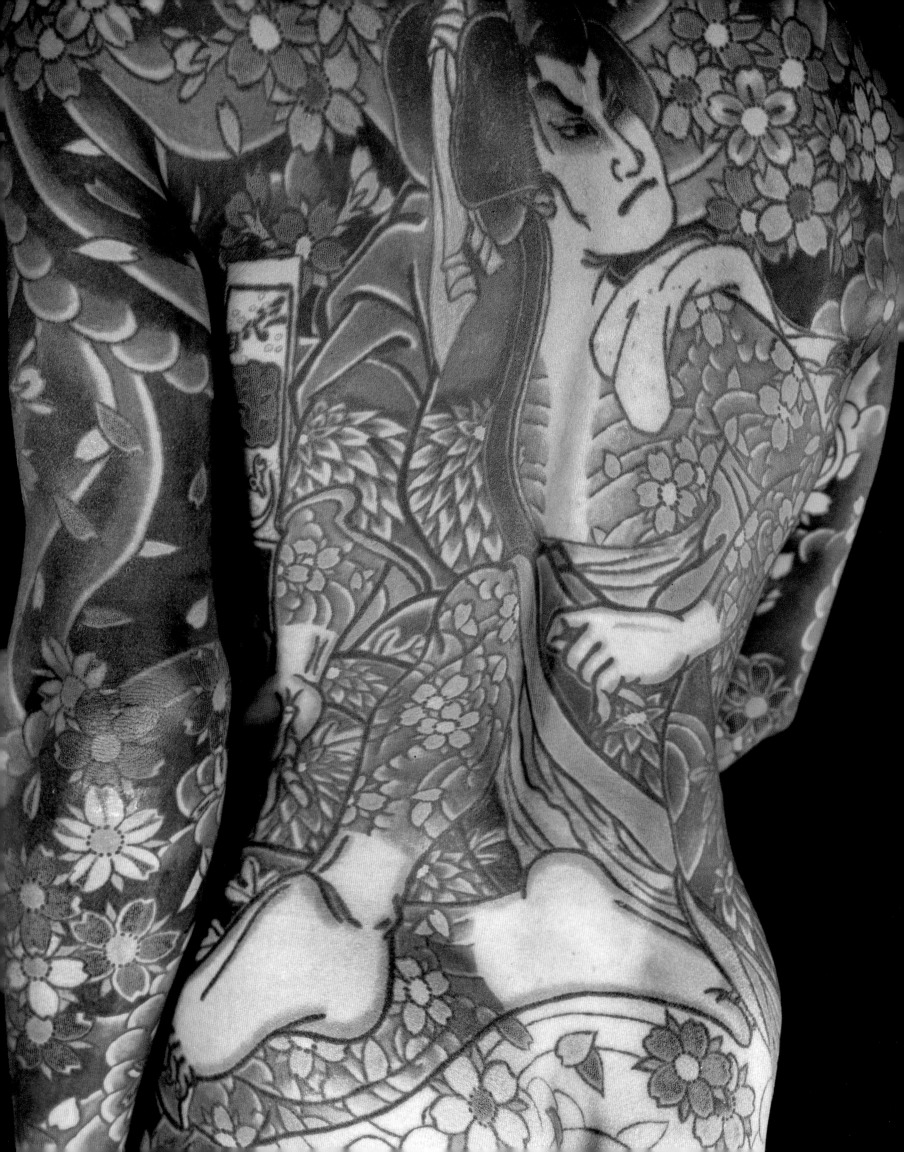

BRAVERY Here Horiyoshi III depicts another tattooed hero from the *Suikoden*, the famous Chinese novel about the exploits of a band of 108 brave warriors.

SPIDERWEB The client requested "a delicate and detailed image" for his underarm, one of the most painful areas to be tattooed and also one of the most dangerous. The needle pricks are constantly subjected to excretions from the sweat glands. The underarm hair suggested to Horikin the idea of a furry spider's web. The spider in Japan has dual meaning: if seen in the daytime, good luck; at night, misfortune.

Spiderweb is also the nickname of a famous American tattoo artist. There seems to be a universal respect for the complex delicacy of this natural phenomenon. The inherent contradiction of the spider, which creates beauty to capture and kill, reflects some of the preoccupations of the irezumi.

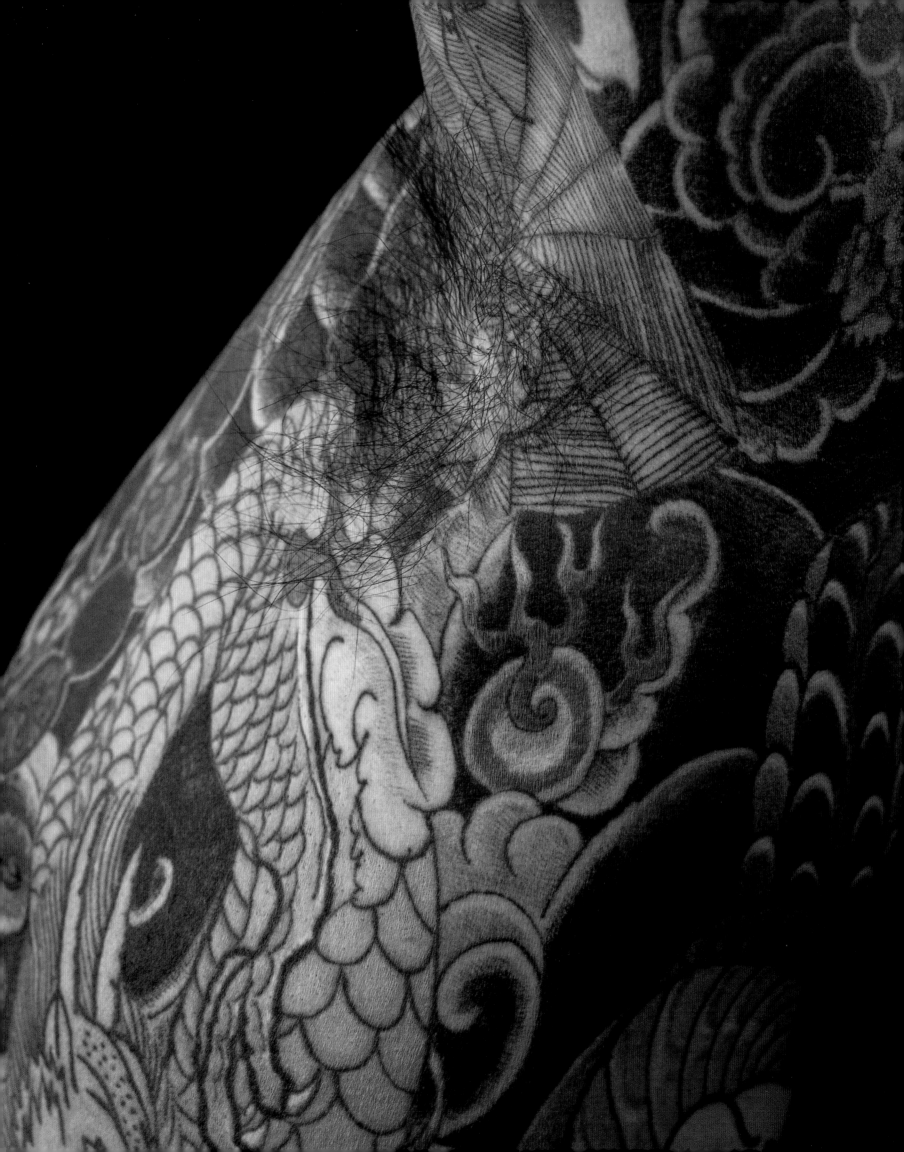

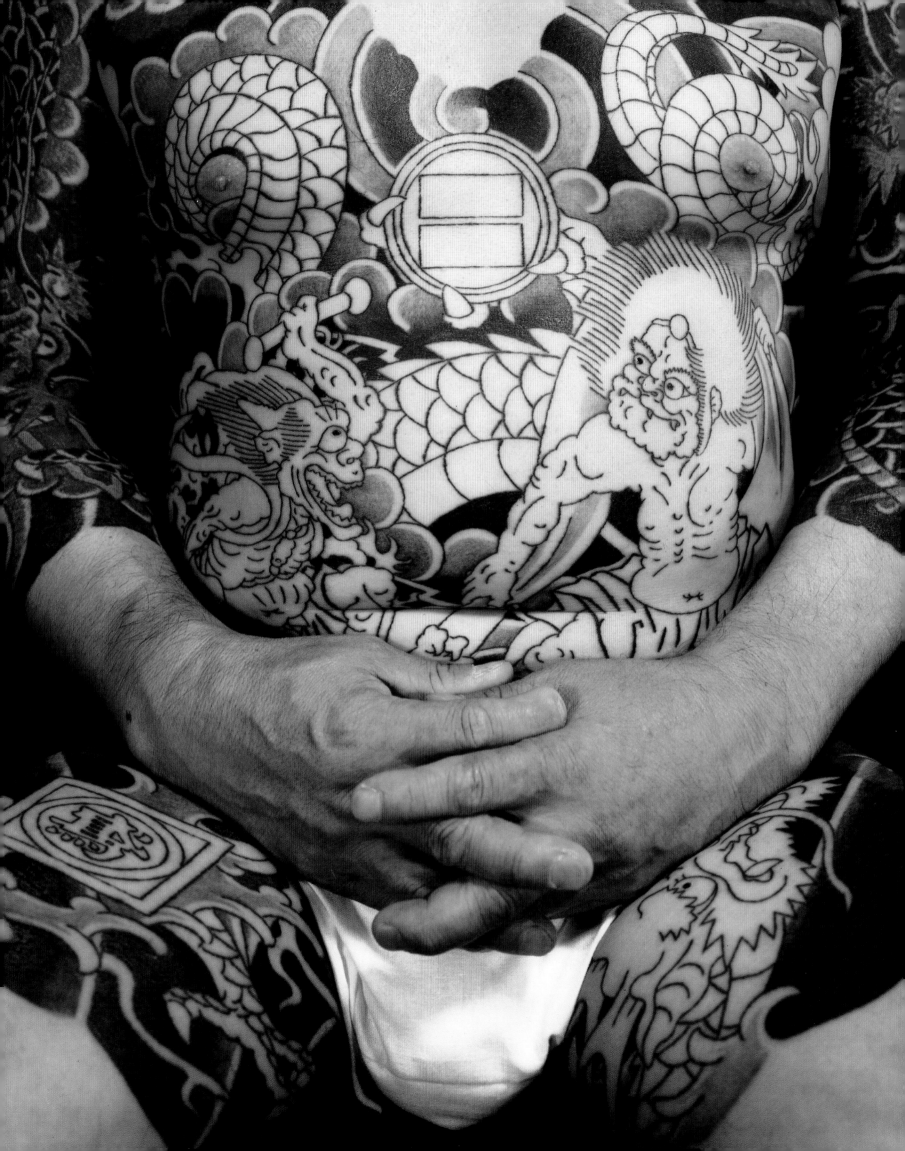

WIND AND LIGHTNING In this unusual monochrome tattoo by Horiichi III, the circular medallion at the solar plexus between the dragon-tail nipples is probably the code logo of a Yakuza group of buddies, or *nakama.* It is a stylization of a rice cooker, and its hidden meaning is that "he who eats from the same pot is a brother." Right, mid-chest, Fujin, God of the Winds and another of the twelve Deva Kings of Buddhism, is always depicted as a clawed demon. Here he is engaged in combat with a comical, laughing dragon of rain. On the subject's right thigh is the secret name of the group within the group, a wild bird.

DEATH AND BEAUTY A beauteous courtesan is haunted by the specter of old age, death, and disease.

GRACE (right) A tattoo terminated at this point. Like Kabuki, where every onstage moment if arrested would make a perfect picture, so, too, the tattoo even at its beginning should stand as beautiful although incomplete. The subject here is a jazz musician with, of course, no connection to the Yakuza.

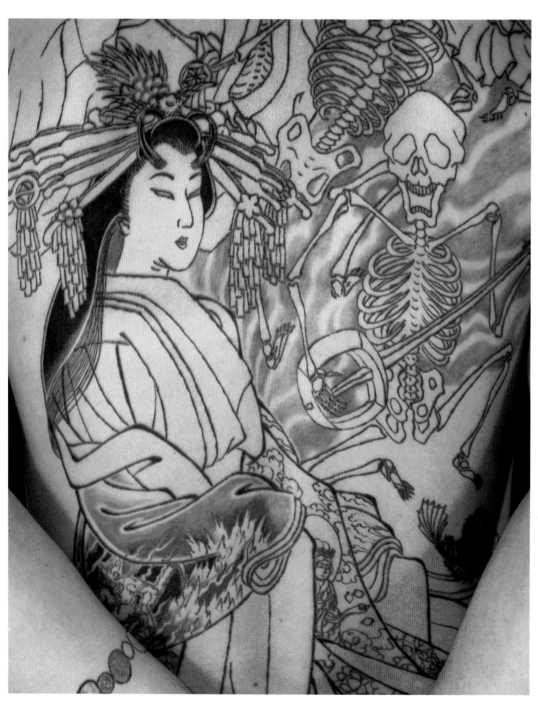

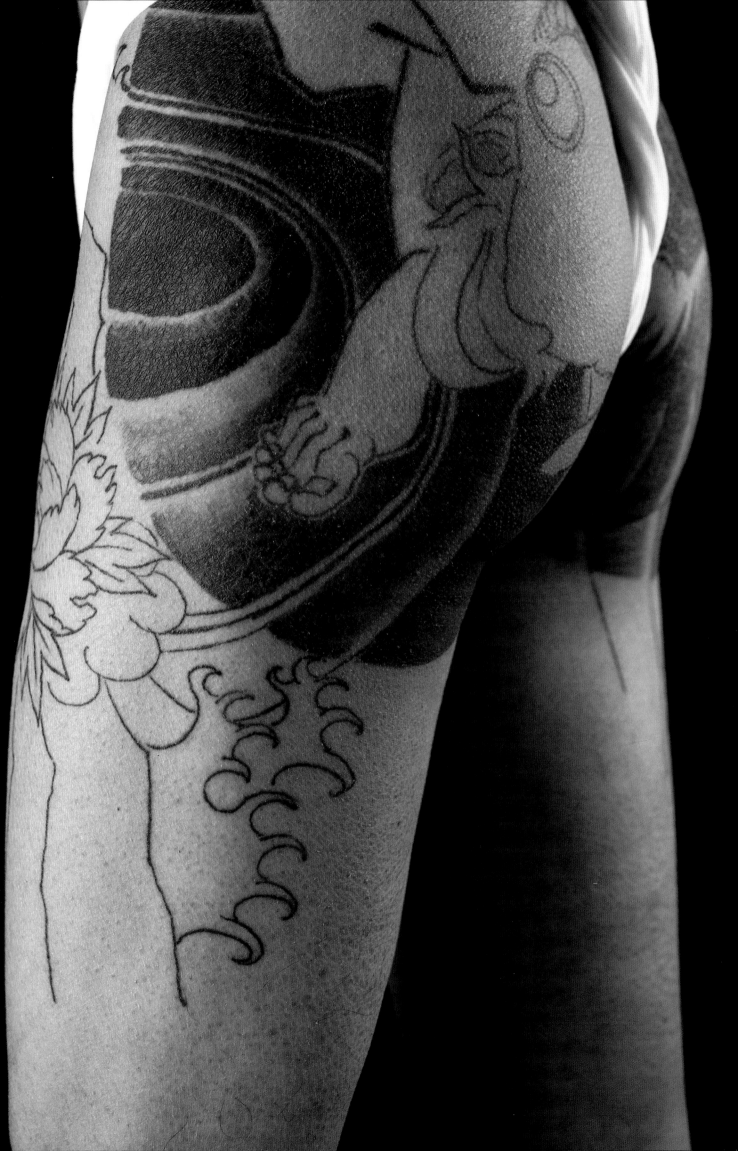

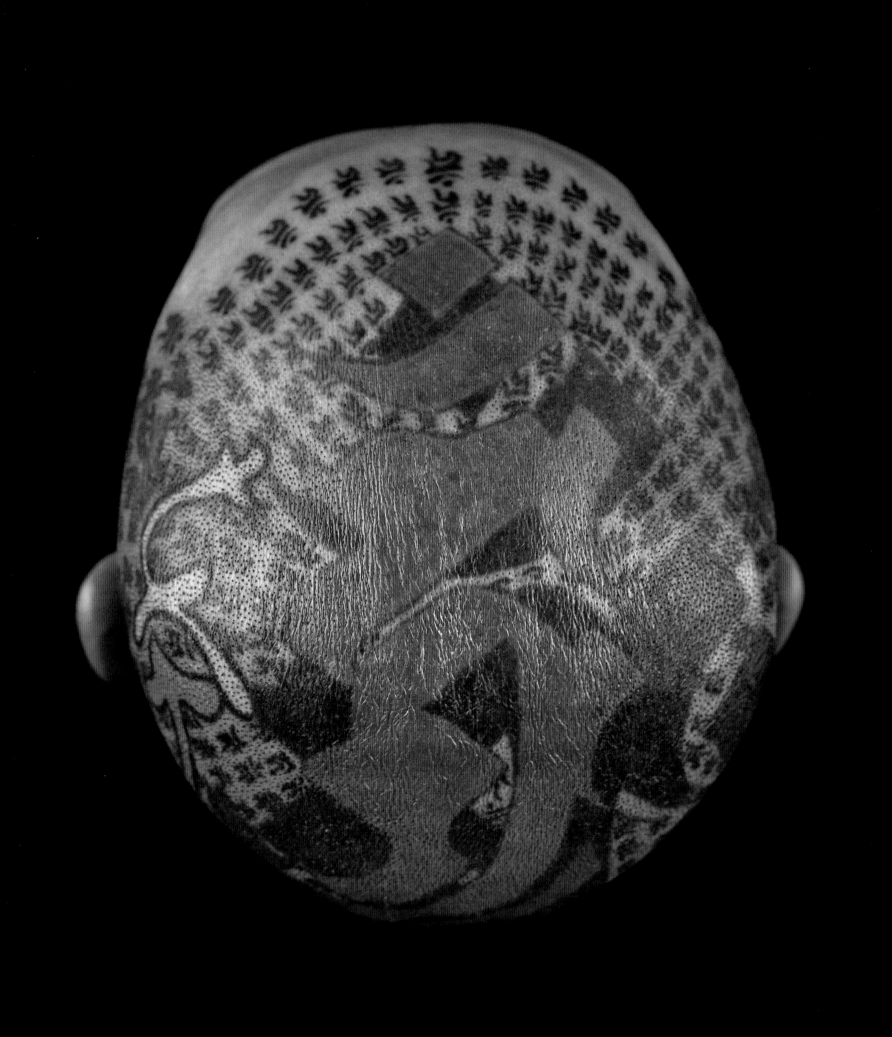

ACKNOWLEDGMENTS

First, I'd like to thank Donald Richie for introducing me to the world of irezumi, and then Faubion Bowers for his all-encompassing knowledge of the world of Japan, past and present. I'm particularly grateful to Eelco Wolf, Barbara Hitchcock, and the Polaroid corporation for making the use of a remarkable camera possible. At Abbeville Press, I'd like to acknowledge the help of Mark Magowan, Walton Rawls, and Jim Wageman. Among the others who were of aid in seeing this project through are Alexandra Monroe of Japan Society, Karen and John Reuter, Elise Meyer, Frank and Julie Parvis, Charles Nafman, Lauren Shakely, Anne Zeman, Gamma One, the late Patrick Cunningham, Linda Lennon, Karen Capucilli, the late Steven Bernardi, and my sister Peggy Fellman in America.

In Japan I'm especially grateful to Yamamoto, Yamada, and Yamasaki at Photo Gallery International. And, of course, I could not have done the book without the full cooperation and aid of Mitsuaki Ohwada. At Japan Polaroid, I want to thank Tom Sato and Kanji Enbutsu. For the generous use of their studios, I'm grateful to Fushimi, Watanabe, and staff, especially Rosawa and Sato, and Sugiki and staff. Wayne Springer and Diane Hunt were very kind in helping with translations. And last but not least, I want to express my gratitude to all the tattoo masters and tattooed men and women who so patiently and faithfully worked with me, especially Satoh and Fukabori.

A NOTE ABOUT THE CAMERA

The camera with which these pictures were taken is one of only five in the world. It was generously made available for my use in Japan by Polaroid Corporation. Five feet high and three-and-a-half feet wide, it weighs two hundred pounds. Using standard Polacolor ER film in rolls, the camera provides an image twenty by twenty-four inches. As with other Polaroid cameras, the film is processed in the back of the camera, with a normal developing time of sixty to seventy seconds. Most of the pictures in this book were taken with a 600mm lens and forty-eight inches of bellows extension, resulting in life-size images in full color.

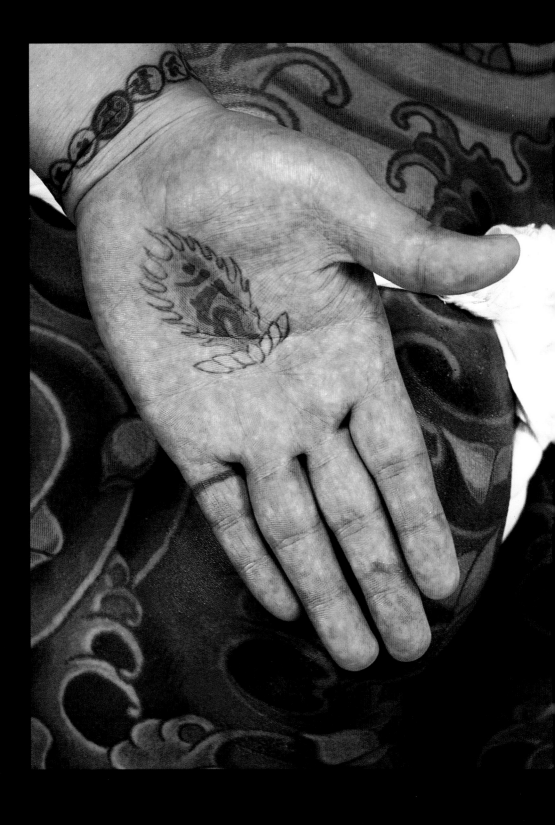

LIST OF PLATES